Old Masters

AT THE ART INSTITUTE OF CHICAGO

THE ART INSTITUTE OF CHICAGO

ISSN 0069-3235

ISBN 0-300-11951-8

Executive Director of Publications: Susan F. Rossen; Editor of *Museum Studies*: Gregory Nosan; Designer: Jeffrey D. Wonderland; Production: Sarah E. Guernsey; Photo Editor: Sarah Hoadley; Subscription and Circulation Manager: Bryan D. Miller.

This publication was typeset in Stempel Garamond; color separations were made by Professional Graphics, Rockford, Illinois. Printed by Meridian Printing, East Greenwich, Rhode Island.

Distributed by Yale University Press, New Haven and London.

This publication is volume 32, number 2 of *Museum Studies*, which is published semiannually by the Art Institute of Chicago Publications Department, 111 South Michigan Avenue, Chicago, Illinois, 60603-6404.

For information on subscriptions and back issues, consult www.artic. edu/aic/books/msbooks or contact (312) 443-3786 or pubsmus@artic.edu. Wholesale orders should be directed to Yale University Press at (203) 432-0966.

This publication was made possible in part by a generous gift from the Old Masters Society of the Art Institute of Chicago. Ongoing support for *Museum Studies* has been provided by a grant for scholarly catalogues and publications from the Andrew W. Mellon Foundation.

Front cover: p. 34, fig. 1 (detail).
Opposite: p. 54, fig. 12 (detail).
Back cover: p. 83, fig. 11 (detail).

Contents

Acknowledgments

In this issue of *Museum Studies* our goal is to explore the kind of works—Old Masters in various media—that the Art Institute's founders initially sought to acquire in order to distinguish and define the museum's collection. In the case of drawings and tapestries, the following essays focus on objects that have been in our holdings for some time and about which we have interesting new information, thanks to diligent research. Other articles concern relatively recent acquisitions—a Renaissance painting, a late Gothic sculpture, and eighteenth-century pastels, which were briefly discussed in recent *Museum Studies* issues but now receive a more extensive and comprehensive treatment.

This publication is the product of the research and skills of a large number of museum staff members. First, I would like to thank my authorial colleagues, who contributed the very readable and scholarly essays: Bruce Boucher in the Department of European Decorative Arts and Sculpture, and Ancient Art; Suzanne Folds McCullagh in the Department of Prints and Drawings; Christa C. Mayer Thurman in the Department of Textiles; and outside experts Koenraad Brosens and Nicholas Turner. In many cases, these authors were involved in acquiring the works on which they wrote.

Crucial to the project's success was the deft editing of Gregory Nosan, in charge of *Museum Studies* for the Publications Department, who shaped the issue along with his colleague Sarah Guernsey, who coordinated its production with a sharp eye for color and costs. They were admirably assisted by Sarah Hoadley, who managed photography rights and obtained essential comparative illustrations. Jeff Wonderland, of the museum's Department of Graphic Design, Photographic, and Communication Services, was responsible for the issue's beautiful design. In the same department, thanks also go to Jennifer Anderson, Chris Gallagher, Robert Lifson, and Caroline Nutley. Brandon K. Ruud, Elizabeth Stepina, and Virginia Voedisch also offered invaluable assistance, as did the staffs of Professional Graphics, Rockford, Illinois, and Meridian Printing, East Greenwich, Rhode Island.

Finally, we are most grateful to the Old Masters Society of the Art Institute of Chicago, which provided critical funding to insure that this issue would be properly, indeed, magnificently illustrated with many rich, color reproductions that convey the high quality and power of these important objects.

LARRY J. FEINBERG

Patrick G. and Shirley W. Ryan Curator in the Department of Medieval to Modern European Painting and Sculpture

Introduction

The term "Old Masters" was first employed in the nineteenth century to denote a rather elite group of eminent artists, those distinguished and influential painters and sculptors who lived after antiquity (and much of the Middle Ages) and before the modern era—artists such as Giotto, Raphael, Poussin, and Rembrandt. With time the designation has become more elastic and has come to include those who are less well known or even anonymous, also embracing earlier masters and crafts-people skilled in what we today call the decorative arts.

There is some debate as to where one might draw the line, chronologically, between Old Master and modern. Some scholars and museums place the turning point at 1800, while others consider the French Revolution to be a fitting end to the old regime, of art as well as politics. I am comfortable with either of these termini but prefer to see as the pivotal figure the Spanish artist Francisco Goya, a painter who built on age-old artistic traditions but offered a new, intensely subjective and cynical—decisively modern—point of view. Because, in certain respects, Goya's art is a summation of what had come before in Spanish as well as other European art, my introductory essay on the history of the Old Master collection at the Art Institute includes him.

The founders of the Art Institute considered Old Master works particularly desirable. Certainly, this interest had much to do with status and fashion, with the leaders of a young city wishing to associate themselves, through prized old art, with old, enduring cultures, old society, and old wealth. But there were also other, more profound reasons for their attraction to Old Master pictures, particularly Italian and Dutch. American collectors strongly identified with what they perceived to be the values of those past cultures as expressed by certain highly influential nineteenth-century writers. American optimism and the belief in the nobility and freedom of the individual was seen as part of the "Italian Renaissance spirit," which, according to the English writer and artist John Ruskin, involved "firm confidence in its own wisdom." The German historian Jacob Burckhardt saw in Renaissance Florence a rugged individualism and progress attained through the efforts of great men. Following him, the French author Hippolyte Taine revered the passion and originality of the men of the Renaissance and celebrated their high-mindedness, virtue, and, like the American founding fathers, their commitment to an ideal.

By the later nineteenth century, seventeenth-century Dutch art came to be as much admired in America as fifteenth-century Italian painting. The brilliant French critic Théophile Thoré, an ardent believer in democracy, was partly responsible for this ascension. He praised the "realism" of Netherlandish art, with its prosaic scenes of everyday life and landscapes produced out-of-doors, before nature itself. Americans also embraced what they perceived to be the "directness," "truth," and humbleness of Dutch art. Beyond that, they felt a distinct cultural kinship with the Protestant, democratic, and egalitarian Dutch. Indeed, the early Dutch settlers and commercial agents of the northeastern United States, who tolerated all religious and ethnic groups so long as they were industrious and fueled economic growth, had inestimable influence on American values and progress.

Many of the same qualities and perceived values of the Old Masters resonate with us today. For this reason, and an enthusiastic determination to learn from earlier and varied cultures, the Art Institute continues to expand its holdings in these areas. The essays in this issue of *Museum Studies* present some of our most recent and important acquisitions of Old Masters, including a late-fifteenth-century German sculpture and an Italian High Renaissance painting. Also featured are a number of works, some long in the collection, about which new discoveries have been made, notably a group of seventeenth-century Italian drawings and eighteenth-century French pastel portraits and Flemish tapestries. It is our hope that these articles will not only throw new light on the significance of these objects for their respective cultures but also elucidate the continuous connection, in beliefs and aspirations, that they have with our own time.

LARRY J. FEINBERG

A Brief History of the Old Masters in the Art Institute of Chicago

LARRY J. FEINBERG

Patrick G. and Shirley W. Ryan Curator in the Department of Medieval to Modern European Painting and Sculpture

Implausibly, the two Chicago businessmen, a lumber magnate and a civic-minded banker, eyed the building before them, literally built on the ashes of the Great Fire, and imagined a repository of the world's masterpieces of art. Even for tycoons with substantial resources and refined aesthetic sensibilities, such a vision would have been then regarded as almost comically overreaching. For in late 1893, although Chicago had impressively resurrected itself from the devastating blaze of 1871, few would have entertained the idea of an exalted temple of art in the midst of a midwestern *campo vaccino*. Indeed, the precinct in which the eager gentlemen wished to establish this treasure trove was spared neither the miasma of the stockyards from the south nor the desperate squalor of the tens of thousands left jobless and homeless after the close of the World's Columbian Exposition that autumn.

Believing that the days for assembling Old Masters collections had passed, the founders of many American art museums had largely resigned themselves to commissioning plaster casts of famous sculptures or, at best, surrounding their few original pictures with curios, remarkable natural objects that fulfilled the rather antiquated notion of an "encyclopedic" museum. Yet, lumber heir Martin A. Ryerson and financier Charles L. Hutchinson had toured Europe together with their wives (see fig. 1) and had found that significant old pictures could still be acquired—and somewhat reasonably—if one avoided certain shrewd agents such as the connoisseur Bernard Berenson or the art dealer Joseph Duveen. In fact, Hutchinson and Ryerson had already begun to form serious collections of their own by 1890; Hutchinson possessed distinguished portraits executed by the Rembrandt follower Nicolaes Maes, and Ryerson had acquired works by other seventeenth-century Dutch masters.[1]

OPPOSITE: Detail of *The Assumption of the Virgin* (fig. 4).

This predilection for Netherlandish pictures would have guided the men's thoughts as they contemplated the grand, empty edifice that would become the Art Institute of Chicago. Fortunately for Ryerson and Hutchinson, who was to serve as president of the museum for over forty years, a major group of Dutch pictures, in the princely Demidoff collection of San Donato, Tuscany, and Paris, became available in the early 1890s. Precociously, in 1890, the two men made a bulk purchase—with money borrowed from a number of museum trustees—of more than a dozen paintings from the Demidoffs, including *Portrait of an Artist*, then believed to be by Frans Hals, and Rembrandt's fetching *Young Woman at an Open Half-Door* (fig. 2), now considered to be the work of a gifted assistant.[2] These were followed by the acquisition of several other Demidoff paintings of some import, all Netherlandish and mostly Baroque—virtually every one captured with money laid out by Hutchinson and Ryerson, who were subsequently reimbursed by other trustees and good citizens.[3] The risks paid off: by 1899 the Art Institute was attracting half a million visitors annually.

Unsatisfied by this coup, the discerning and opportunistic Ryerson was determined to amplify his own collection—destined for the Art Institute—with pictures by the Italian Renaissance masters, some of whose names marched below the cornice of

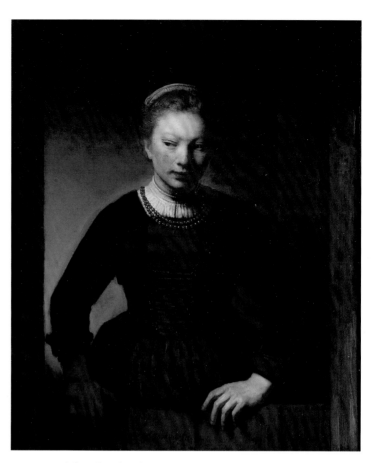

FIGURE 2. Workshop of Rembrandt Harmensz. van Rijn (Dutch, 1606–1669). *Young Woman at an Open Half-Door*, 1645. Oil on canvas; 102.5 x 85.1 cm (40 3/8 x 33 1/2 in.). Mr. and Mrs. Martin A. Ryerson Collection, 1894.1022.

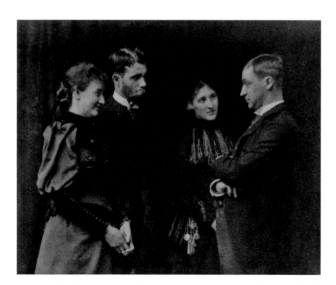

FIGURE 1. Carrie Ryerson, Martin A. Ryerson, Frances K. Hutchinson, and Charles L. Hutchinson, 1891.

the new building. Ironically, the art dealer Georges Durand-Ruel, better known as a champion of French Barbizon and Impressionist painters, bid on Ryerson's behalf and secured his first Italian purchases, ascribed to the Florentine artist Agnolo Bronzino and to Pietro Perugino, Raphael's master.[4] The "Bronzino" (fig. 3) has recently been recognized as an important, lost portrait of the assassinated Duke Alessandro de' Medici by Bronzino's teacher, the sixteenth-century Florentine painter Pontormo. One of Ryerson's favorite pictures, this work remained in his home for many years, entering the museum upon his death in 1932.

Until 1906, when the Art Institute made what was arguably the most spectacular acquisition of the time, the collection consisted primarily of earthy Dutch pictures, a suite of four large architectural caprices by the late-eighteenth-century French artist Hubert Robert, and numerous white plaster casts, which, no doubt, seemed

then not only edifying but tasteful in the context of the recent Columbian Exposition, with its vast complex of wooden "Neo-Classical" buildings and structures starkly whitewashed to resemble marble.[5] But in that year the calm of the Art Institute's ensemble was pierced with the bold purchase of El Greco's stunning *Assumption of the Virgin* (fig. 4), which immediately became the salient axis of the museum's holdings. Such an acquisition was at that time courageous for its $40,000 price tag, its massive scale, and especially for its soaring Catholicism, a quality not appreciated by many of the art-collecting, East Coast robber barons nor by most civic museums. But, above all, the purchase was remarkable in that El Greco was then little known beyond a small circle of art specialists, his expressively elongated figures and oddly phosphorescent colors an acquired taste. Only with publications in the 1920s by German art historians, who drew parallels between El Greco's abstracted figures and those in twentieth-century German Expressionist art, did his work receive proper consideration and admiration.

This partly explains why almost a decade passed between the time the museum received the altarpiece, after buying the work with money borrowed from the Northern Trust Bank, and the year in which a local donor was found to pay off the loan; responding to entreaties from Hutchinson and Ryerson, Nancy Atwood Sprague, honoring her late husband, Albert, an Art Institute trustee who had founded a successful wholesale grocery company, supplied the needed funds in 1915 (just a year before her death). When the picture first arrived, some of the board members had grave concerns about taking out the large bank loan (close to $50,000, including the interest payment), and the acquisition was only approved by the slimmest of margins, in an official vote of seven to six. Such reluctance was understandable; thirteen Demidoff pictures, mainly by better-known artists, had been obtained for about $200,000. Also of some relevance may have been the fact that, before the picture went to Chicago, the Impressionist painter Mary Cassatt had lobbied her close friend Louisine Waldron Elder (Mrs. Henry Osborne) Havemeyer to acquire the work from Durand-Ruel (who had established a gallery in Manhattan some years before) and to place it

in an American museum. Apparently, because New York's Metropolitan Museum of Art, the principal recipient of Mrs. Havemeyer's largesse, already had a smaller painting by El Greco—and its staff did not express sufficient enthusiasm for the *Assumption*—she decided to pass on it. Cassatt then, reportedly, spoke to Martin Ryerson's wife, Carrie.

In any case, impressed with the Sprague gift and the acquisition of the grand El Greco, the Chicagoan Eveline M. Kimball, widow of William Wallace Kimball, founder of the Kimball Piano and Organ Company, decided to put a large part of her collection on loan to the Art Institute in the summers of 1915 and 1916. Previously, she had proudly opened her Prairie Avenue mansion on occasion to those interested in viewing what she and her husband had acquired. Among the Kimballs' pictures were fine seventeenth-century Dutch and French Barbizon landscapes and a few significant

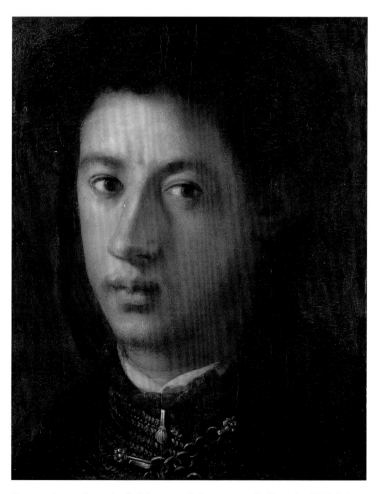

FIGURE 3. Jacopo Carrucci, called Pontormo (Italian, 1494–1557). *Alessandro de' Medici*, 1534/35. Oil on panel; 35.3 x 25.8 cm (13 7/8 x 10 1/8 in.). Mr. and Mrs. Martin A. Ryerson Collection, 1933.1002.

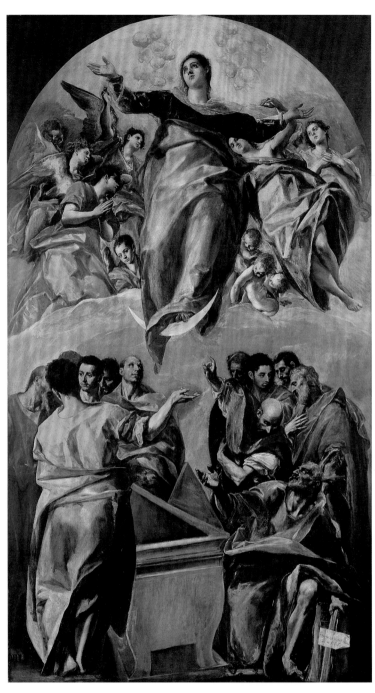

FIGURE 4. Domenico Theotokópoulos, called El Greco (Spanish, born Greece, 1541–1614). *The Assumption of the Virgin*, 1577. Oil on canvas; 401.2 x 228.7 cm (158 x 90 in.). Gift of Nancy Atwood Sprague in memory of Albert Arnold Sprague, 1906.99.

Monets. But the core of their holdings consisted of British works from the eighteenth and nineteenth centuries, including compositions by Thomas Gainsborough, Thomas Lawrence, John Constable, J. M. W. Turner, and Joshua Reynolds, notably his celebrated *Lady Bunbury Sacrificing to the Graces* (fig. 5), which received much public attention when Mrs. Kimball purchased it in 1915 for the breathtaking sum of $100,000.[6] She could well afford it, as the large Kimball organ was at that moment beginning to become a fixture in theaters across the country, with the burgeoning popularity of silent movies. When she passed away just six years later, virtually all of her pictures went to the museum, among them Rembrandt's *Portrait of an Old Man with a Gold Chain*, the first and only unquestioned painting by the master to enter the Art Institute's collection.[7]

Whether the El Greco altarpiece, a relative bargain, ended up in the museum by luck or by pluck, the industrialist and art collector Charles Deering may have been the most excited man in Chicago. An heir to the fortune of William Deering, founder of an agricultural implement manufacturer that merged with the McCormick family's farm equipment company to become International Harvester, Deering was a serious devotee of Spain and Spanish art. He had already possessed a modest El Greco painting by 1908, just one of many works he had obtained for Mar y Cel, his retreat at Sitges, near Barcelona. Deering likely imagined his own pictures in the place of the Hubert Robert architectural views that incongruously flanked the *Assumption* in the first decades of the century, the result of the trustees' attempt to create an impressive concentration of Old Masters. Eventually, this came to pass, as he emptied Mar y Cel and bequeathed the lion's share of his Spanish collection to his family, which they, in turn, have given to the Art Institute over the years. This assortment of works includes ceramics, metalwork, sculpture, and, among its paintings, possibly the most important fifteenth-century Spanish picture in the New World, Bernat Martorell's magnificent *Saint George Killing the Dragon* (fig. 6).

As part of this familial benevolence, Deering's brother James, his daughters, and descendants have donated or placed on long-term loan numerous other paintings from their collections, including Giovanni Battista Tiepolo's four scenes from Torquato Tasso's epic poem *Jerusalem Liberated*, Pompeo Batoni's suave *Portrait of Sir Edward Dering*, and Francisco Goya's farcical *Boy on a Ram*.[8]

Although both Hutchinson and Ryerson would have been enthusiastic about Deering's pictures, the Antiquarians, the Art Institute's first affiliate group, would have particularly welcomed his family's gifts of decorative arts. Originally known as the "Chicago Society of Decorative Art," the organization changed its name in 1894 to the "Antiquarians" when it decided to focus solely on "antiquities," as distinct from contemporary and amateur handicrafts.[9] From the beginning, the group was determined to purchase a broad range of sculptures and decorative art objects, including textiles, furniture, enamels, porcelains, glass, jewelry, and other objects of gold and silver. These pieces were officially the property of the society, which, having been assigned its own galleries, functioned as a branch or fiefdom of the Art Institute. Already by 1891, the Antiquarians had acquired, on the advice of the museum's director, William M. R. French, some rare Spanish church needlework pieces. In 1900 Ryerson greatly increased their holdings of textiles and museum "furnishings" with a bequest of thirty-seven brocades and fabrics dating from the fifth through sixteenth century, along with some Flemish tapestries and various curios.

Within and without the museum building, the Antiquarians also encouraged the collecting of fine decorative art objects by hosting elaborate exhibition receptions and elegant soirées. Individual members, notably the livestock and banking heir Robert Allerton, contributed to the cause through private donations and parties of their own; clad in glamorous Asian robes, Allerton frequently held court over assemblies of museum curators and socialites, likewise dressed in togas and kimonos, mingling in

the well-appointed rooms of his farmland "manor" house. Although acknowledged for this nimble, if grandiose, cultivation of collectors and his donation of myriad art objects (Renaissance *cassone* chests, Jacobean furniture, porcelains, and Asian pottery, "host" robes, and screens), he is best remembered for the Art Institute building named

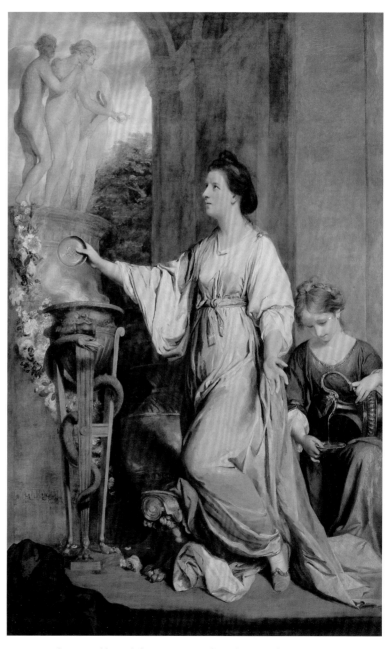

FIGURE 5. Joshua Reynolds (English, 1723–1792). *Lady Bunbury Sacrificing to the Graces*, 1763–65. Oil on canvas; 242.6 x 151.5 cm (95 ½ x 59 ¾ in.). Mr. and Mrs. W. W. Kimball Collection, 1922.4468.

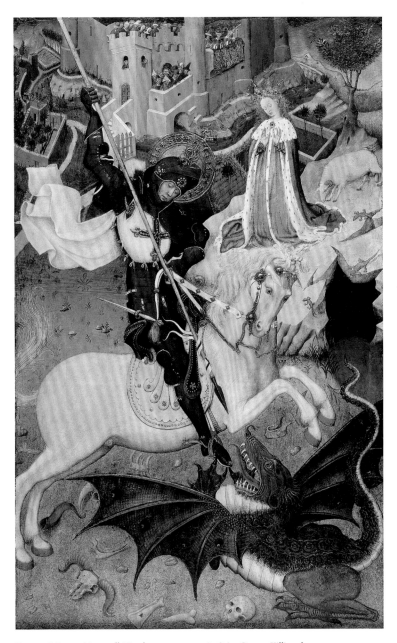

FIGURE 6. Bernat Martorell (Catalan, c. 1400–1452). *Saint George Killing the Dragon*, 1434/35. Tempera on panel; 155.6 x 98.1 cm (61 ¼ x 38 ⅝ in.). Gift of Mrs. Richard E. Danielson and Mrs. Chauncey McCormick, 1933.786.

Chauncey J.) Blair, a woman of sophisticated taste married to a prominent Chicago banker, filled her Paris apartment with medieval and Renaissance works, eventually selling many at auction but leaving some of her best pieces, among them French Gothic architectural fragments, to the museum. Taking advantage of the federal Payne Bill of 1909, which repealed the 20 percent tax levied on artworks imported into the United States, Blair brought her Parisian collection in 1914 to Chicago, where the museum trustees and staff artfully staged an exhibition of her varied objects.

Beyond the grasp of the Antiquarians, the fiercely independent art collector Kate Buckingham, who vowed never to belong to any "club, church, or man," led her own regime at the Art Institute in the 1920s.[10] In 1924 her extensive collection of fifteenth- and sixteenth-century French architectural fragments, furniture, sculptures, and tapestries was installed in the museum's Lucy Maud Buckingham Memorial Gothic Room, named for Kate's beloved late sister. While few of these works were to remain in the collection—Buckingham herself acknowledged the inferiority of many of them before her death in 1937—she left the Art Institute the outstanding print collection of her late brother, Clarence, and an endowment that provided for the purchase of an extraordinary array of objects throughout the late 1930s and early 1940s, including the powerful *Head of an Apostle* (fig. 7) from the Cathedral of Notre-Dame in Paris—perhaps the most significant piece of Gothic sculpture in North America.

Understandably, aside from the Buckingham funds, the museum did not have the wherewithal to purchase many works, Old Master or otherwise, during the period of the Great Depression. But Martin Ryerson's death in 1932 and that of his widow five years later entailed the largest single bequest of Old Master pictures (and of art in general) in the Art Institute's history. This gift provided the core of the museum's Italian Renaissance collection, ranging from Apollonio di Giovanni's rich, mythological *cassone* panels to Ugolino di Nerio's *Virgin and Child Enthroned with Saints*, inspired by the Trecento Sienese master Duccio, and

in his honor in recognition of his bounteous financial contributions—the building that holds the majority of the museum's Old Master paintings and sculptures.

Other Antiquarians of that period, especially those who possessed second residences abroad and could acquire objects "at the source," bequeathed to the Art Institute some of their treasures. For instance, Mary Mitchell (Mrs.

including masterworks by the likes of such major central Italian painters as Lorenzo Monaco and Perugino.[11] Most prominent in the bequest was a group of six panels by the eccentrically inventive fifteenth-century Sienese master Giovanni di Paolo, which depicts scenes from the life of Saint John the Baptist (see fig. 8). Ryerson's taste for finely detailed and intricate pictures extended to early French and Netherlandish paintings as well, and he left to the museum particularly representative works by the Flemish artist Rogier van der Weyden and the French painter Jean Hey, also known as the Master of Moulins.[12]

Inspired by the Ryersons, another lumber heir, Charles H. Worcester, together with his wife, Mary, formed a collection with the intention of donating to the museum various Old Master pictures, primarily Italian, German, and Netherlandish (with some French), that would complement the Ryerson bequest. To this end, consulting with the Art Institute's curators, many of them recent scholarly émigrés from Germany, and the museum's then director, Robert Harshe, the Worcesters decided to concentrate on Venetian and other northern Italian pictures in order to flesh out the

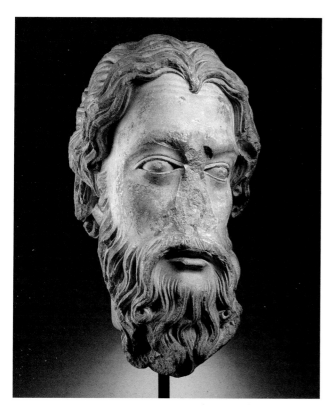

FIGURE 7. *Head of an Apostle*, c. 1210. Cathedral of Notre-Dame, Paris, France. Limestone with traces of paint; 43.2 x 25.5 x 26 cm (17 x 10 ¹/₄ x 10 ¹/₁₆ in.). Kate S. Buckingham Endowment, 1944.413.

FIGURE 8. Giovanni di Paolo (Italian, active in Siena by 1417, died 1482). *Saint John the Baptist Entering the Wilderness*, 1455/60. Tempera on panel; 68.5 x 36.2 cm (27 x 14 ¹/₄ in.). Mr. and Mrs. Martin A. Ryerson Collection, 1933.1010.

FIGURE 9. Peter Paul Rubens (Flemish, 1577–1640). *The Wedding of Peleus and Thetis*, 1636. Oil on panel; 27 x 42.6 cm (10 ⅛ x 16 ⅝ in.). Charles H. and Mary F. S. Worcester Collection, 1947.108.

Italian holdings. This strategy resulted in the museum's eventual acquisition of paintings (between 1929 and 1947) by many of the then lesser-known masters of the Venetian and Lombard schools, such as Jacopo Bassano, Ercole de' Roberti, and the gifted Brescian portraitist Giovanni Battista Moroni.[13] From the Worcesters, the museum also received three panels—*The Crucifixion, Adam,* and *Eve*— by the major sixteenth-century German painter Lucas Cranach the Elder. But, failing to land important pictures by the great Venetian triumvirate of Titian, Tintoretto, and Veronese, the Worcesters enjoyed their greatest success in procuring seventeenth-century paintings for their collection, purchasing what is generally considered to be the masterpiece of the Roman artist Bartolommeo Manfredi— *Cupid Chastized* (1605/10)—a free variant on a lost work by Caravaggio, and the Flemish master Peter Paul Rubens's assured oil sketch *The Wedding of Peleus and Thetis* (fig. 9). Drawing on the major acquisitions fund established by the Worcesters, and following their tastes, the museum subsequently bought paintings by two of Rubens's principal assistants and followers: Jacob Jordaens's *Temptation of the Magdalene* and Frans Snyders's fulsome *Still Life with Dead Game*.[14]

Although, like Martin Ryerson, largely (and rightly) remembered today for her contributions of French Impressionist and Postimpressionist pictures to the museum, Bertha Honoré (Mrs. Potter) Palmer purchased (and her son Honoré later donated) what is, inch for inch, one of the Art Institute's most important and accomplished early sculptures, the exquisitely realized, fourteenth-century *Corpus of Christ* by the Netherlandish artist Jacques de Baerze (fig. 10). Commissioned by Philip the Bold, Duke of Burgundy, and intended for his family tomb in the Charterhouse of Champmol near Dijon, the small, carved walnut piece was one of only a few early works known to have come into Mrs. Palmer's collection. Interestingly, she acquired the *Corpus* in 1910, perhaps galvanized— like other Antiquarians—by the charismatic sculptor and dealer George Grey Barnard, who advocated the purchase of Gothic works in a lecture at the Art Institute that year.

Her prescient acquisition came two decades before the celebrated Guelph Treasure exhibition of 1931, which brought to the city eighty-two ecclesiastical objects ranging in date from the eleventh through the fifteenth century and which stimulated a minor medieval craze among local collectors (sometimes manifested in the purchase of early German prints, Flemish "primitive" paintings, and the fanciful renovation of building lobbies).[15]

During the period of World War II, the museum began to direct its attention seriously to prints and drawings that were long in its possession but generally neglected due to a lack of in-house expertise. The trustees had founded the Department of Prints and Drawings in 1911, and some of the first works on paper had entered the collection decades earlier. But the first major boost to that area of the Art Institute's holdings came from the geologist and paleontologist William F. E. Gurley, who, at the beginning of the century, had avidly collected drawings, in bulk, in London, and gave over 4,500, greatly varying in quality, to

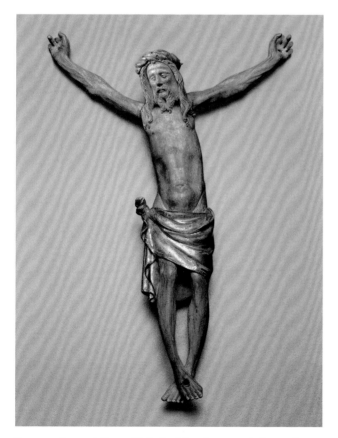

FIGURE 10. Jacques de Baerze (Netherlandish, active 1383–92). *Corpus of Christ*, 1390/91. Walnut with traces of polychromy and gilding; 27.7 x 18.3 x 5.2 cm (11 x 6 1/4 x 2 1/16 in.). Gift of Honoré Palmer, 1944.1370.

the museum in 1922 (another 2,300 or so were bequeathed at his death). Five years later, Charles Deering donated over 5,200 prints, along with some splendid drawings, including a lively study of a shepherd by the sixteenth-century Italian painter Francesco Parmigianino.[16] The holdings were much expanded in the late 1930s with the bequest of the Clarence Buckingham Collection, which provided over 1,100 prints, many significant Old Masters among them, and ample purchase funds. However, aside from intermittent attention paid by the eminent German art historian Ulrich Middeldorf, who joined the faculty of the University of Chicago in 1935 and who started to draft a catalogue of the drawings, the works on paper generally languished untouched.

This changed in 1940 with the appointment, as curator of prints and drawings, of Carl O. Schniewind, a connoisseur of French art who immediately began to sort through the museum's holdings and make some determinations regarding attribution and quality. Albeit a decidedly mixed bag, the Gurley holdings, which William donated in memory of his mother, Leonora Hall Gurley, yielded some very important sheets (some only discovered long after Schniewind's tenure), including superb drawings by the sixteenth-century Italian masters Federico Barocci and Giorgio Vasari, and by the seventeenth-century Bolognese artist Guercino (see pp. 51–58).

Although his print collection was wide ranging, with many nineteenth-century works, Deering seems to have concentrated on the "canon" of Old Masters, especially seeking good impressions of prints by the German artist Albrecht Dürer, Rembrandt, and Goya. This group of works was later grandly augmented by the 1919 gift of Old Master prints, primarily early German works, from one of Bertha Palmer's sons, Potter Palmer, Jr., and, afterward, from his widow throughout the late 1940s and early 1950s (until her bequest in 1956); these were joined by pieces from the Buckingham Collection, which included a choice assembly of Dürer and Rembrandt prints. Stimulated by two exhibitions of early illuminated manuscripts at the Art Institute in 1915 and 1922, both sponsored by the dealer Wilfrid F. Voynich, the museum added to its prints and drawings collection a number of important medieval and Renaissance leafs and cuttings, such as *Historiated Initial O with Moses* by the famous fourteenth-century Italian illuminator Don Silvestro dei Gherarducci and a beautiful leaf depicting the Annunciation from a mid-fifteenth-century Belgian Book of Hours.[17]

As Schniewind came to identify what was in the collection, he also came to recognize its gaps and worked to fill them. In this enterprise, he was aided by the Buckingham Fund as well as, most admirably, Margaret Day Blake, a champion of suffrage and other progressive reforms for women and the first president of the Woman's Board of the Art Institute of Chicago. She provided financial support for many of Schniewind's purchases of French and Italian drawings, among them rare, early studies by the artists Giovanni Badile (believed at the time of its acquisition to be by Rogier van der Weyden) and Pisanello.[18] Years later, similar partnerships were established by drawings curator Harold Joachim, first with Margaret Blake and, more closely, with Helen Regenstein (widow of the paper and chemical industrialist, Joseph), who enabled the museum to expand greatly its holdings of eighteenth-century French and Italian drawings.[19]

Like that of works on paper, the textile collection grew quietly by accretion, and only at the time of World War II did it begin to receive focused and careful attention. On trips to Europe in the 1890s, Martin Ryerson had gathered hundreds of textiles and encouraged his fellow museum trustee, the industrialist Edward E. Ayer, to follow suit. Ayer later bequeathed his textiles to the Industrial Art Division of Chicago's Field Museum, but, when that department was eliminated in 1906, the Art Institute was able to purchase Ayer's large collection. To these extensive holdings prized works were added by Robert Allerton and Emily Crane Chadbourne, grandniece of Ryerson and a plumbing supply heiress who kept a residence in Paris, where she became a member of Gertrude Stein's circle.[20] With such an impressive assemblage of pieces, ranging from the thirteenth through eighteenth century, including magnificent sixteenth- and seventeenth-century Italian and Spanish silks and Flemish and Italian tapestries (see fig. 11), it became clear by 1940 that the museum needed a staff member specifically dedicated to this material. Consequently, Mildred Davidson was appointed the first textile curator and, thereafter, with the advice and financial support of Belle M. (Mrs. Chauncey)

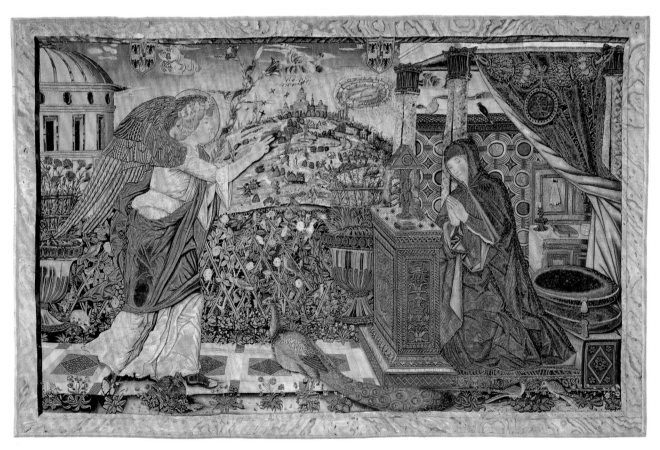

FIGURE 11. Circle of Andrea Mantegna (Italian, 1431–1506). *Hanging Depicting the Annunciation*, 1484/1519. Wool, silk, and gilt- and silvered-metal-strip-wrapped silk, slit, dovetailed, and interlocking tapestry weave; 178.8 x 114.6 cm (70 3/8 x 45 1/8 in.). Gift of Mr. and Mrs. Martin A. Ryerson, 1937.1099.

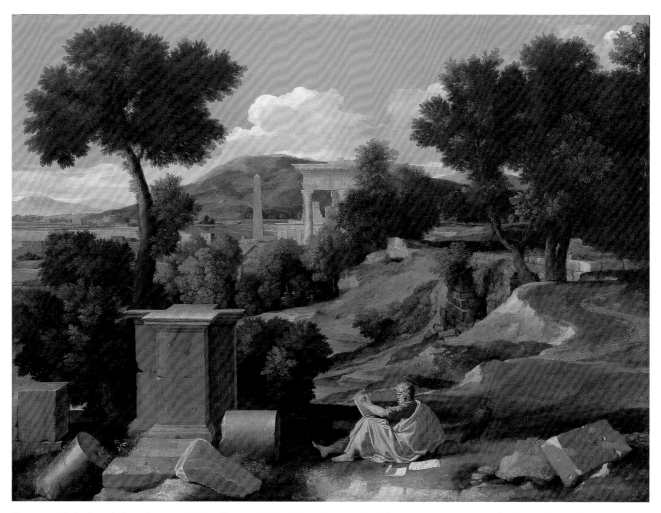

FIGURE 12. Nicolas Poussin (French, 1594–1665). *Landscape with Saint John on Patmos*, 1640. Oil on canvas; 100.3 x 136.4 cm (39 ¹/₂ x 53 ³/₈ in.). A. A. Munger Collection, 1930.500.

Borland, the well-informed and discriminating wife of a Chicago stockbroker, the collection began to be augmented in a more reasoned and proactive manner.[21]

During the war, and in its aftermath, the museum prospered with an acceleration in the quantity and kinds of objects donated as well as in the number of donors. The patronage of the graphic art and textile collections grew—even the Chicago department store Marshall Field and Company donated a handsome group of seventeenth- and eighteenth-century tapestries in the early 1950s—and the Deering clan (long since united with the McCormicks through marriage) continued their generous pattern of gift giving. They were joined, however, by other, new benefactors to the museum, including Alexander A. McKay, nephew and principal heir of Alfred A. Munger, one of the

museum's early supporters, and Max and Leola Epstein. President of a successful elevator company founded by his father, Munger had bequeathed to the Art Institute, in 1898, mainly negligible nineteenth-century French paintings. But, decades later, in tribute and memoriam, McKay, who was a banker, established a purchase fund in his uncle's name that allowed the museum to acquire two of the most outstanding Old Master pictures in its collection: one of the most important Trecento paintings outside of Italy, a powerful Crucifixion by the thirteenth-century Italian artist known as the Master of the Bigallo Crucifixion, and the majestic *Landscape with Saint John on Patmos* (fig. 12) by the preeminent seventeenth-century French master Nicolas Poussin, considered by many the most significant pre–nineteenth-century French painting in the museum.[22]

17

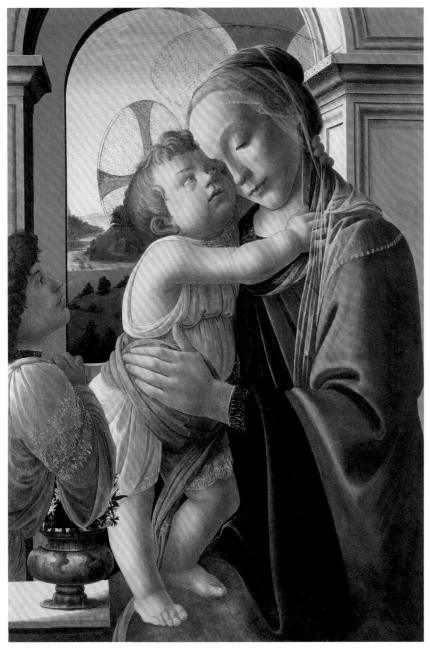

left to the museum, recent scientific investigations have confirmed that the beautiful *Virgin and Child with an Angel* (fig. 13) was indeed created by the hand of the master and not by a shop assistant. Likewise, Epstein's quite elegant, eighteenth-century *Fête champêtre*, ascribed to the French artist Jean-Baptiste Pater when it entered the museum, appears instead to be the work of Pater's exalted master, Jean-Antoine Watteau, the inventor of the *fête galante* genre.[23]

While he may have been slightly less discerning than his contemporary, Epstein, the colorful collector George F. Harding, Jr., lacked none of his acquisitive passion. The formidable real estate baron and politician, whose large, chiseled head and bearing evoked General George S. Patton, built on the eclectic holdings of his father, compulsively amassing an array of objects that included arms and armor and European decorative arts, paintings, and sculpture, mainly military in theme.[24] In 1930 he installed this wealth of material in a "castle" museum on Chicago's South Side. More than twenty years after his demise in 1939, the building was dismantled, its contents eventually finding their way to the Art Institute in 1982. Overnight, the museum became a major repository of well-crafted firearms, halberds, powder flasks, and suits of armor. Highlighting the Harding cache were dazzling examples of three-quarter

FIGURE 13. Sandro Botticelli (Italian, 1445–1510). *Virgin and Child with an Angel*, 1475/85. Tempera on panel; 85.8 x 59.1 cm (33 ¾ x 23 ¼ in.). Max and Leola Epstein Collection, 1954.283.

field armor from late-sixteenth-century Milan (see fig. 14) and elaborately decorated Austrian and German wheel-lock rifles and pistols. Hidden among the weaponry were some fascinating paintings, notably two sixteenth-century Netherlandish panels—Jacob Cornelisz. van Oostanen's clamorous *Adoration of the Christ Child* and the evocative *Landscape with Tournament and Hunters*, recently determined to be the work of Jan van Scorel.[25]

Epstein, a financier who first displayed some of his pictures in an exhibition at the Art Institute in 1928 and bequeathed his collection in 1954, has proved to have been especially astute in his art purchases. Although scholars had occasionally expressed some doubt concerning the autograph status of one of the two Botticelli paintings he

With the growing scarcity and, consequently, increasingly high prices of major Old Master works over the past fifty years, fewer bequests and purchases have been made en masse. This is particularly true of paintings, which in recent decades the museum has judiciously acquired in serial fashion. Although foremost a collector of early American art, European textiles, and Japanese woodblock prints, Emily Crane Chadbourne gave the Art Institute, in 1951, a small but fine selection of eighteenth-century English group portraits, known as "conversation pieces," by Arthur Devis and others.[26] Also after the war, and throughout the 1960s, several important Italian Renaissance pictures were acquired by means of various restricted acquisition funds, notably Jacopo Tintoretto's dynamic *Tarquin and Lucretia* (in 1949) and depictions of the *Virgin and Child with the Young Saint John the Baptist* by both Corregio (in 1965) and Jacopo Bassano (in 1968).[27]

In the late 1960s and 1970s, the Art Institute significantly expanded its holdings of seventeenth- and eighteenth-century French paintings, thanks largely to

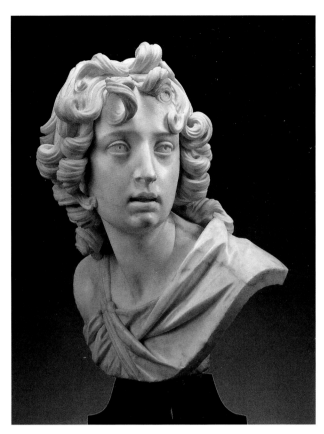

FIGURE 15. Francesco Mochi (Italian, 1580–1654). *Bust of a Youth*, 1630/40. Marble; 40.5 x 33 x 29 cm (15 7/8 x 13 x 11 1/8 in.). From the collection of the estate of Federico Gentili di Giuseppe. Restricted gift of Mrs. Harold T. Martin through the Antiquarian Society, 1989.1.

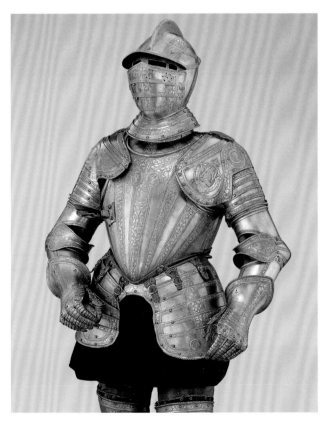

FIGURE 14. *Three-Quarter Field Armor*, 1570/80. Milan, Italy. Steel, gilding, iron, brass, and leather; h. 177.8 cm (70 in.). George F. Harding Collection, 1982.2102a–t.

monies supplied by the Charles H. and Mary F. S. Worcester Fund and by museum trustee Eloise W. (Mrs. Harold T.) Martin, who contributed to the purchase of many sculptures and decorative art objects as well. These years saw the acquisition of a number of excellent pictures by interesting, if little-known, French masters, such as Laurent de La Hyre, Eustache Le Sueur, and Jacques-Antoine Volaire. Always gracious and supportive, Mrs. Martin, whose husband founded the Martin Oil Company, also provided funds for some key additions in the 1980s, among them the Italian sculptor Francesco Mochi's striking marble *Bust of a Youth* (fig. 15). Eloise Martin also supported the purchases of a pair of pictures by Pierre-Henri de Valenciennes illustrating episodes from the life of Alexander the Great, and an exquisite, porcelain *Mourning Madonna* by Franz Anton Bustelli.[28]

With the extensive renovation of the museum and construction of a new wing, the Daniel F. and Ada L. Rice

FIGURE 16. Pompeo Girolamo Batoni (Italian, 1708–1787). *Peace and War*, 1776. Oil on canvas; 136 x 99 cm (53 ¹/₂ x 39 in.). Gift of the Old Masters Society, 1989.152.

Building, in the late 1980s, the Art Institute's galleries took on a new, more severe aesthetic as "decorative ensembles" gave way to a more spacious, chronological placement of works. Gaps in the Old Master paintings and sculpture collection became more obvious, although they were mitigated by the display in the surrounding galleries of prints and drawings, which well represented particular artists' and period styles. Despite the diminished availability of Old Master works—and intense market competition—the museum has continued to fill some of these lacunae in the past twenty years. Important works by the late-sixteenth-century Dutch Mannerist master Joachim Wtewael and the seventeenth-century Dutch painters Albert Cuyp and Paulus Potter have entered the collection along with major pictures by

Italian Baroque artists, namely Luca Giordano, Jusepe de Ribera (a Spaniard who worked in Naples), and Giovanni Baglione—the last painting instigating an infamous lawsuit between the artist and the hotheaded Caravaggio, who, feeling he had been plagiarized, issued libelous statements and poems about Baglione.[29] The museum enhanced its eighteenth-century installations with an unusually fresh Venetian cityscape by Francesco Guardi, a landscape by the prominent English artist Joseph Wright of Derby, and a beautifully preserved allegory by Pompeo Batoni (fig. 16) that joins his portraits and religious works in the collection.[30] This last painting was one of several works acquired through funds raised and offered by the Old Masters Society, the support group for the Department of Medieval through Modern European Painting and Modern European Sculpture, which has also provided necessary funds for the reframing of many Old Master pictures.

The Textile Society, founded in 1978, just a year after the Old Masters, has been no less active, partially funding the crucial conservation in Belgium of some of the Textile Department's admirable tapestry holdings.[31] Under the guidance of Christa C. Mayer Thurman, curator of textiles at the museum since 1968, adequate facilities for conservation, display, and storage were developed in-house, and the holdings have grown to become one of the most comprehensive collections of textiles in the United States. In recent years, a number of significant pieces have been added to the superb collection of tapestries, altar cloths, ecclesiastical vestments, orphrey bands, and other textiles that were donated or purchased over the years with funds bequeathed by Robert Allerton, Belle M. Borland, Kate Buckingham, Grace R. Smith, and many others. Among the more outstanding acquisitions in the past two decades were the purchases, in 1992, of two beautiful bands and three fragments from a fourteenth-century Florentine orphrey (see fig. 17) related in style to the works of the eminent painter Taddeo Gaddi, and, in 1993 and 1995, the seventeenth-century English *Stafford Chasuble* and *Stafford Altar Frontal*.[32]

The venerable Antiquarians and some of that society's individual members, particularly Eloise W. Martin, have provided funds for the purchase of important sculptures and decorative art objects that have handsomely fortified the seventeenth- and eighteenth-century galleries in recent years. The seventeenth-century works include bronzes by the Italian sculptors Alessandro Algardi and Ferdinando Tacca, a terracotta *Pietà* by the Genoese master Filippo

Parodi, and a brilliant silver cup in the form of a rearing horse, created by the German silversmith Hans Ludwig Kienle. Eighteenth-century French sculptor Jean-Antoine Houdon's marble bust of the Comtesse de Pange now regally presides over the Batonis and Roberts, and displayed in an adjoining corridor is a recently acquired Bacchic relief by the English sculptor John Deare.[33]

Other nearby corridors contain an extraordinarily rich assortment of works on paper. Building on the accomplishments of Helen Regenstein and Harold Joachim, who developed the Art Institute's collection of French Rococo drawings in particular, the museum's curators and donors have patiently assembled a strong group of eighteenth-century pastel portraits over the past two decades (see pp. 72–87). Moreover, the Regenstein Foundation and some active benefactors, notably museum trustee Anne Searle Bent and the late Dr. William D. Shorey, have allowed the Art Institute to obtain several extremely important early

FIGURE 17. *Fragment from an Orphrey Band depicting Saint Mark*, 1360s. Florence, Italy. Linen, plain weave; underlaid with linen, plain weave; embroidered with silk, gilt-and-silvered-metal-strip-wrapped silk in split and surface satin stitches; laid work, couching, and padded couching; 17.6 x 14.2 cm (6 7/8 x 5 1/2 in.). Robert Allerton Endowment, 1992.742d.

drawings, prominent among them studies by the sixteenth-century Florentine masters Baccio Bandinelli and Pontormo (fig. 18). Dr. and Mrs. Shorey also enabled the museum to purchase one of the earliest known monotype prints, *God Creating Adam*, by the seventeenth-century Genoese artist Giovanni Benedetto Castiglione.[34]

The largest single drawings gift in the past ten years has come from the highly knowledgeable, Boston-based collector Dorothy Braude Edinburg, who, in 1998, presented to the museum twenty-eight very important sheets and has pledged another fifty Old Masters, part of a total promised gift of about 240 drawings. This impressive group, which was mounted in exhibitions at the Art Institute in 1998–99 and 2006, includes major studies from fifteenth-through seventeenth-century France, Holland, Italy, and Spain, and particularly strong pieces from eighteenth- and early-nineteenth-century France and Italy. The collection contains, for example, accomplished drawings by Italian Renaissance master Giulio Romano, Dutch still-life painter Jan van Huysum (see fig. 19), and leading Rococo artists Watteau and François Boucher.[35]

The museum benefited as well in these years from the generosity of museum trustee Jean Goldman and her husband, Steven, who underwrote an extensive renovation

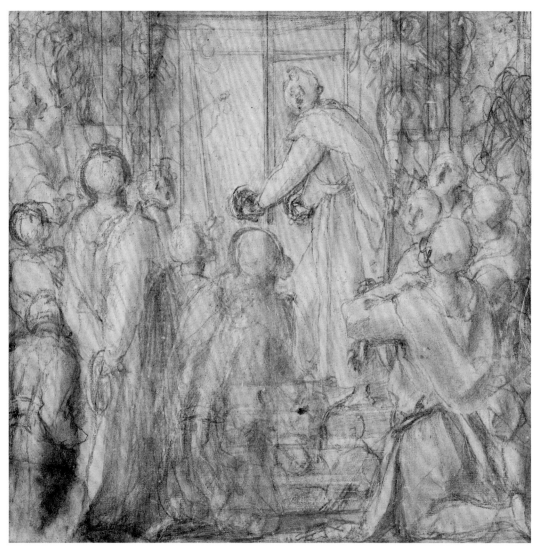

FIGURE 18. Jacopo Carrucci, called Pontormo. *Christ before Pilate*, 1522/23. Black chalk, with stumping, and traces of red chalk, heightened with traces of white chalk, over stylus incising, on cream laid paper; 27.4 x 28.3 cm (10 7/8 x 11 1/8 in.). Restricted gift of Anne Searle (Meers) Bent, the Regenstein Foundation, and Dr. William D. Shorey, 1989.187.

of the Prints and Drawings Department and Study Room and have promised their strong, scholarly collection of Italian drawings from the sixteenth and seventeenth centuries. Also assembling a world-class collection of Renaissance and Baroque drawings from Italy, Anne Bent has given several important sheets to the museum, including a beautiful study by the Emilian painter Correggio. During this same period, museum trustee David C. Hilliard and his wife, Celia, a Chicago social historian, have donated more than thirty drawings, mainly nineteenth-century, but among them outstanding sheets by such Old Masters as the Medici court artist Giovanni Stradano and the eighteenth-century French painters Jean-Baptiste Oudry and Gabriel de Saint-Aubin.[36]

Complementing—and equal in quality and breadth to the recent drawings and paintings acquisitions—is the Alsdorf Collection of Renaissance Jewelry, eighty-one pieces given to the Art Institute in 1992 by the sagacious collector and museum trustee Marilynn B. Alsdorf. Elegant and admirable objects in themselves, these carefully chosen works illuminate Renaissance and Baroque attitudes toward antiquity (some reuse ancient cameos) and enhance our understanding of the jewelry portrayed in various Old Master pictures and sculptures.[37]

It is thus no surprise that Marilynn Alsdorf, Anne Bent, and the Hilliards were among the contributors, along with several other generous trustees and Old Master Society members, who facilitated, in just the past year, the purchase of the Art Institute's first major Italian High Renaissance painting, the intimate, jewel-like *Nativity* (1506/07; see p. 34, fig. 1) by the Florentine master Fra Bartolommeo, a very gifted contemporary of Leonardo da Vinci and Raphael. Perhaps commissioned by King Louis XII of France and much esteemed in its day, this work fulfills a long-standing desire of the museum's founders and curators, who wished for over one hundred years to have a painting in the collection

FIGURE 19. Jan van Huysum (Dutch, 1682–1749). *Flowers in an Urn Decorated with Putti on a Plinth*, early 18th century. Brush and gray and red wash, pen and black ink, and red chalk on cream laid paper, laid down on cream laid paper; 38.6 x 29.7 cm (15 ¼ x 11 ¹¹⁄₁₆ in.). Gift of Dorothy Braude Edinburg to the Harry B. and Bessie K. Braude Memorial Collection, 1998.112.

that represents this serene apogee of Italian art in the early decades of the sixteenth century. We can be fairly confident that Martin Ryerson would have welcomed this finely rendered picture into the midst of his splendid assortment of early Italian, Flemish, and French paintings. It is a masterpiece that bridges the divide between his beloved Perugino and Pontormo, and that speaks quietly to some of the lofty aspirations that he and Charles Hutchinson announced high across the facade of the museum in 1893.

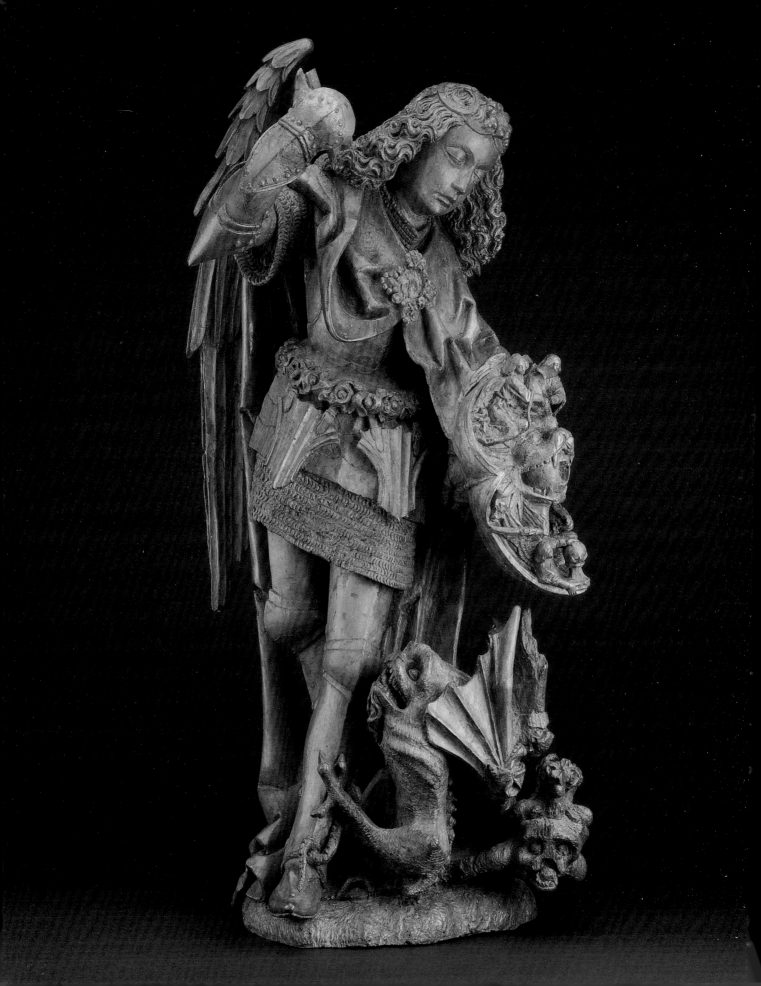

"*War in Heaven*": Saint Michael and the Devil

BRUCE BOUCHER

Eloise W. Martin Curator of European Decorative Arts and Sculpture, and Ancient Art

The recent acquisition of *Saint Michael and the Devil* (fig. 1) has notably strengthened the Art Institute of Chicago's presentation of fifteenth-century northern European sculpture. Carved from a single block of poplar wood, it is a masterpiece, evoking religious imagery characteristic of the period of transition from late medieval to Renaissance art. As such, it joins major works in the museum's collection like *Corpus of Christ* by Jacques de Baerze (see p. 15, fig. 10) and *Reliquary Bust of Saint Margaret of Antioch* by Nicolaus Gerhaert.[1] At the same time, the statuette presents a different type of religious work, embodying the distinctive tradition of late Gothic sculpture in Spain, a tradition that has been in the shadow of Spanish painting until comparatively recent times.

While the rediscovery of Spanish painting was greeted with universal acclaim from the early nineteenth century, sculpture was less readily welcomed.[2] For non-Catholics, there were religious and aesthetic prejudices to surmount; moreover, Spanish sculpture seemed flagrant in its departure from classical standards, its emphasis upon color and hyper-realism proving fatal to critics steeped in the Neoclassical works of Antonio Canova and Bertel Thorwaldsen. Thus, Richard Ford, a contemporary English connoisseur who became an important advocate of Spanish painting, could liken Spanish sculptures to "painted dolls" or "tinsel images," complaining that they "could only please the ignorant and children."[3] This dismissal echoed Michelangelo's famous remark about Netherlandish art having a kind of naturalism only appreciated by nuns and other simple souls, but, in writing this, Ford was simply endorsing what connoisseurs outside of Spain had been saying for centuries. Influential figures such as the sixteenth-century artist and biographer Giorgio Vasari or the eighteenth-century art historian Johann Joachim Winckelmann argued that true sculpture should be equated with

OPPOSITE: FIGURE 1. *Saint Michael and the Devil*. Hispano-Flemish, 1475/1500. Poplar; 52.4 x 22.9 x 21.3 cm (20 1/8 x 9 x 8 3/8 in.). Chester Tripp Endowment, 2004.721.

25

white marble, monumental forms, and the imitation of the antique.[4] By contrast, Spaniards favored pigmented wood or clay as vehicles of expression; indeed, Francisco Pacheco, a noted painter and the first great Spanish art historian, wrote in 1622 that "the figure of marble or wood requires the painter's hand to come to life."[5] This expectation of naturalistic coloring distinguished the Spanish aesthetic in sculpture and also underscored the cleft between sculpture in Spain and elsewhere in Europe.

Any analysis of the Art Institute's *Saint Michael* must bear in mind this history of critical reception. Although stripped of its polychrome surface, the work nonetheless embodies an alternative to the great tradition of Italian Renaissance sculpture, emphasizing instead painterly qualities that had more in common with Netherlandish art than with the revival of antiquity. The work possesses a linear sharpness and attention to detail characteristic of that synthesis of Netherlandish and Iberian taste sometimes dubbed "Hispano-Flemish." Whether it is the product of a Northern sculptor active in Spain or a Spanish sculptor working under the influence of Northern models remains, for now, unresolved; it is, however, a remarkable instance of an artistic heritage that has survived in only a fragmentary fashion.[6]

The origins of the Hispano-Flemish style are better grounded in documentation than in extant works of art, but they can be traced back to visits by the great Flemish painter Jan van Eyck to Portugal and Spain in the late 1420s. Van Eyck made paintings as diplomatic gifts, and, in his wake, artists such as Rogier van der Weyden and Hugo van der Goes painted altarpieces for Spanish patrons and influenced many Spanish painters with their limpid depictions of the world through the new medium of oil paint. King Juan II of Castile owned the *Triptych of the Virgin* by Van der Weyden, better known as the *Miraflores Triptych*, and this work, among others by that artist and his followers, influenced Castilian artists throughout the fifteenth century.[7] For Spanish patrons and their artists, the empirical naturalism of the Flemish School cast a powerful spell, often seeming to eclipse contemporary stylistic currents from Florence. There was also a similarly close contact between Northern sculptors and their Spanish counterparts during the fifteenth century. Janin Lommé from Tournai and his collaborator, Juan de Bruselas, were active in Pamplona from 1425, and the masons' lodges of cities such as Burgos, Léon, Seville, and Toledo record artists with names like Juan Alemán, Hanequin de Bruselas,

and Jan van Mechlen. In addition, entire wood altarpieces were shipped from the Netherlands to Spain in the second half of the fifteenth century, a phenomenon reflective of the demand for Northern sculpture on the Iberian Peninsula. The increased trade and diplomatic contact that followed the spread of Habsburg dominance over Burgundy and, ultimately, Spain itself, further enhanced such artistic links.

The symbiosis of Netherlandish and Spanish art continued until 1566, when the revolt of the Spanish Netherlands provoked a wave of iconoclasm in which zealous reformers destroyed many religious works of art and effectively ruptured that area's artistic heritage. In Spain, unrest of a different but no less disastrous sort occurred

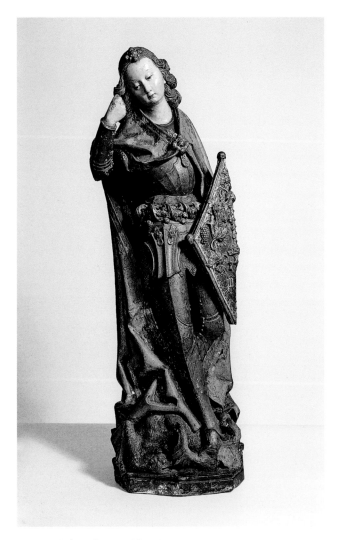

FIGURE 2. Pedro Millán (Spanish, active c. 1487–1515). *Saint George*, c. 1490. Terracotta and paint; 91 x 26 cm (35 7/8 x 10 1/4 in.). Victoria and Albert Museum, London, A.6-1943.

early in the nineteenth century, provoked by the War of Independence and the French occupation, which lasted from 1808 to 1814. While looting and the spoils of war introduced the rest of Europe to the glories of Spanish art, many of these works, especially smaller pieces of sculpture, were irreparably severed from their original contexts. At the same time, the growth in antiquarian collecting across Northern Europe beginning in the late eighteenth century stimulated the demand for stained glass, Gothic furniture, and what a Christie's sale catalogue on 1825 termed "ancient and very curious carvings in wood. . . . suitable for the fitting up of private chapels . . . [and] Gothic mansions."[8] As the nineteenth century wore on, such works gained popularity beyond antiquarian circles and were recognized as the embodiment of a style every bit as significant as the artistic renaissance south of the Alps.

The *Saint Michael* embodies this tradition as well as reflecting the handiwork of a major artist. The saint is shown in a dynamic pose, his head and upper torso turning to the viewer's right while his left leg and lower torso pivot in the opposite direction. In his raised right hand, he holds the remains of a lance with which he fixes Satan, here depicted in the guise of a devil. Like a creature out of the works of Hieronymus Bosch, this devil seems part dragon, part bird, with multiple heads and claws; what

color is left on the sculpture's surface can still be seen in its gaping mouths (see fig. 1). The contrast between the calmly triumphant Michael and the writing devil could hardly be more pointed, and this essential idea is amplified through the saint's accoutrements, which are themselves miniature tours-de-force: the once bejeweled cloak framing his body, the carefully observed details of his mail and armor, and, above all, the splendidly evocative shield, with its high-relief detailing. Originally polychromed and encrusted with semiprecious stones, the sculpture would have been an object of critical admiration as much as religious adoration, and its intimate scale suggests that it once formed part of a private chapel's décor. The degree of detail and the complexity of the pose further indicate that the figure was designed to be seen from more than one viewpoint, encouraging the viewer to follow the direction of the saint's lance and marvel over the fidelity with which his armor was portrayed and the overall richness of effect.

The subject of Saint Michael would also have been appropriate for such a context, as it embodied the triumph of good over evil as related in the Book of Revelation:

And there was war in heaven: Michael and his angels fought against the dragon; and the dragon fought and his angels, and prevailed not; neither was their place

FIGURES 3–4. Details of the shields of *Saint George* (at left) and *Saint Michael and the Devil* (at right).

27

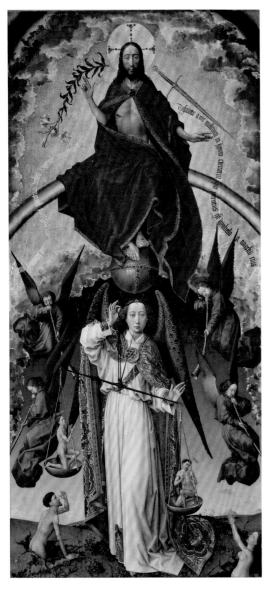

FIGURE 5. Rogier van der Weyden (Flemish, 1399/1400–1464). *The Last Judgment* (central panel), 1443/53. Oil on panel; 212 x 101 cm (83 ½ x 39 ¾ in.). Musée de l'Hôtel-Dieu Beaune.

found any more in heaven. And the great dragon was cast out, that old serpent, called the Devil, and Satan, which deceived the whole world: he was cast out into the earth, and his angels were cast out with him (Revelation 12: 7–9).

This image enjoyed popularity from the early Middle Ages onward, and Michael was generally depicted as a youthful figure of noble bearing, clad in armor and triumphantly poised to vanquish his enemy.[9] The saint became a multivalent symbol, too, for he could represent the battle between good and evil over the Christian soul—he was often shown weighing souls at the Day of Judgment—as well as the more general triumph of Christianity over its enemies. Like paintings of the Last Judgment or an illumination from a book of hours, the Art Institute's sculpture would have encouraged private meditations on the fate awaiting all Christian souls at the second coming of Christ. Over the centuries, the image of Saint Michael evolved with changing fashions, and the armor shown here is consistent with a kind worn in Europe during the latter part of the fifteenth century. As we shall see, it invites comparison with a number of similar images from this period, all of which can be associated with Spain.

When the *Saint Michael* first appeared on the art market, it was the subject of an extensive analysis by the German scholar Dorothee Heim, who situated the work in the cosmopolitan center of Seville, which had an active sculptural heritage focused on the great cathedral of Santa Maria de la Sede.[10] Local sculpture received a fresh impetus from the presence of Lorenzo Mercadante, a transplant from Brittany, who was a dominant figure between 1454 and 1467.[11] Mercadante created a number of works in alabaster and wood, and established a tradition of terracotta sculpture later continued by Pedro Millán and Pietro Torrigiano, a Florentine. In particular, Millán appears to have completed his training in Seville, and his best-known works include maiolica roundels of saints Cosmas and Damian (1504; Santa Paula, Seville) and a statue of Saint James the Greater (1506; Santa Maria de la Sede, Seville). They reflect very clearly what has been described as "the Spanish manner of dealing with the types and style of Northern late Gothic," which is to say a figural style less linear and more three-dimensional, with facial types less forbidding than their Northern prototypes.[12] It was to Millán that Heim attributed the Art Institute's sculpture on the basis of a comparison with one of his most notable creations, a signed terracotta of Saint George now in the Victoria and Albert Museum, London (fig. 2).[13] Her case was based substantially on the similarity between the two sculptures, and, at first glance, the resemblance appears striking. Beyond the basic concept, the poses of the figures are complementary, with only some variations in the stance of the legs and the placement of the dragon. Enveloped in long, flowing mantles, both hold elaborately embossed shields in their left hands and are wearing comparable suits of armor.

It is true that both works share a similar, highly decorative style; yet their points of resemblance can more plausibly be explained through common subject matter and prototypes. Millán was primarily known as a worker in clay, whereas the author of the Chicago *Saint Michael* was clearly a superlative woodcarver. Moreover, the London sculpture is almost twice the size of the Art Institute's work, and its figure is much flatter and far less plastic. This flatness stems from the fact that the *Saint George* was probably cast from a mold whereas the *Saint Michael* is carved in the round. In this context, a comparison of the two shields is telling: Saint George's shows a cross surrounded by vines and placed above a crown of thorns, alluding to Christ's Passion, while

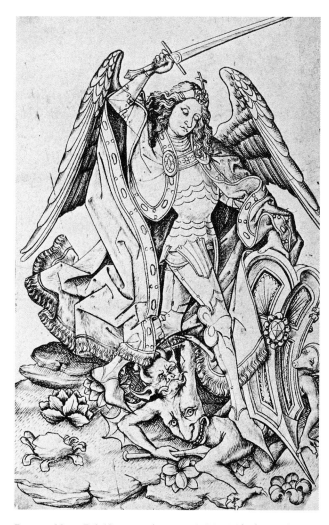

FIGURE 7. Master E. S. (German, active 1450–67). *Saint Michael*. Engraving on paper; 14.4 x 19.1 cm (5 ⁹/₁₆ x 3 ⁹/₁₆ in.).

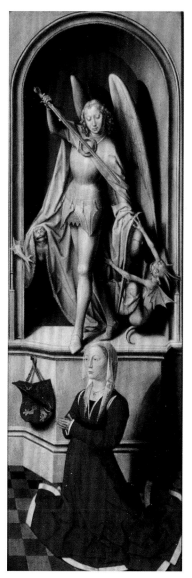

FIGURE 6. Hans Memling (Flemish, 1430/40–1494). *The Last Judgment* (outer panel), 1467. Oil on panel; 223.5 x 72.5 cm (88 x 28 ¹/₂ in.).Muzeum Narodowe, Gdansk, MNG/SD/413/M.

Saint Michael's has a lion's head framed by angels bearing a cartouche and the chalice as a sign of Christ's sacrifice (see figs. 3–4). Both shields were conceived very differently and reflect the diverse nature of their media; the terracotta example is flatter and given over to a simpler scheme of liturgical imagery, while its wood counterpart is literally excavated to form an image of great plasticity. Beyond that, the hair and the facial types of the two warrior saints can be distinguished from one another because Millán's figures—including this one—tend to have more slender, oval faces with smoothly swept-back hair. In contrast, the sculptor of the *Saint Michael* favored a squarer, broader head with hair that falls in ringlets. The same variance can be found in the conception of the adversary at each saint's foot, for Saint George's dragon is a relatively flat

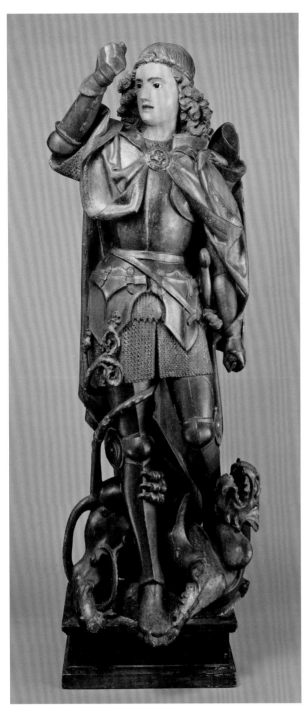

FIGURE 8. *Saint Michael.* Hispano-Flemish, late 15th century. Painted wood with gilding and glass; h. 156.5 cm (61 ⅝ in.). Princeton University Art Museum, Gift of Stanley Mortimer, Class of 1919, Y1944-100.

and undifferentiated mass of clay, while Saint Michael's devil is realized in a highly three-dimensional fashion.

It appears unlikely, then, that Millán is the author of both works, but the creator of the *Saint Michael* probably shared a common visual culture and would have known comparable prototypes, which included paintings, prints, and other sculptures of the same subject. Prototypes of the Art Institute's *Saint Michael* can be found in two celebrated paintings of the mid-fifteenth century: the central panel of *The Last Judgment* by Van der Weyden (fig. 5) and one of the outer panels of Hans Memling's triptych *The Last Judgment* (fig. 6). Van der Weyden's *Saint Michael* clearly derives from Van Eyck's angels in the Ghent Altarpiece (1432; Cathedral of St. Bavo, Ghent), as does Memling's; in this context Memling's figure is even more suggestive because it is a fictive statue by an artist who saw the sculptural potential of this composition.

One of the most typical means of spreading imagery from northern to southern Europe in this period was the medium of prints, which expanded rapidly during the fifteenth century. Printmakers found an especially profitable vein of imagery in scenes from the lives of Christ and the Virgin that were used for private meditation and in depictions of saints, who were often invoked in times of sickness or need. The Master E. S. was one of the most prolific artists in this genre, flourishing in the Upper Rhineland between 1450 and 1467.[14] His engravings spread across Europe and were widely imitated; many of them were based upon the works of Van Eyck and Petrus Christus, and played an important role in transmitting the linear style and imagery of Netherlandish painting into the realm of sculpture. Heim drew attention to one of his prints in particular, an engraving of *Saint Michael and the Devil* (fig. 7) that anticipates many features in the Art Institute's statuette.[15] Master E. S. depicted the warrior saint about to strike the devil with his sword, and many of the accessories in the wood sculpture can be found here: the cloak, the shield, even the style of the armor are comparable. Other details, such as the treatment of the hair and headband, and a devil with multiple heads, also find parallels here. These similarities suggest that this print or some comparable image served as the ultimate source for the sculptures in Chicago and London. Indeed, this type of warrior saint was so widely present in Spain of this period that it would be hard to single out one work as the model for either sculpture. However, Heim published a stone sculpture of the archangel ascribed to Mercadante and located in the

province of Seville.[16] This work, too, shares many traits with the print of *Saint Michael* by the Master E. S. and also with the terracotta and wood sculptures under review, and it could be easily argued that the Art Institute's statue is the product of an as-yet-unknown sculptor working in the manner of Mercadante.

Although the creator of the *Saint Michael* resists identification, he certainly seems to have been an important representative of Spanish sculpture of the late Gothic period. In particular, numerous parallels in Spanish art of the era can be found for the style of the armor, with its pinched waist, tassets or hanging metal plates, and pointed sabatons covering the feet—all typical of the late fifteenth century.[17] These features are seen in paintings by artists such as Bartolomé Bermejo, Bernat Martorell (see p. 12, fig. 6), and Pere Nisart, as well as analogous devotional sculptures like one in the collection of the Princeton University Art Museum, which conveys an idea of what our sculpture would have looked like when polychromed (see fig. 8).[18] The *Saint Michael* constitutes valuable evidence of the confluence of artistic currents in late-fifteenth-century Spain. When fully painted, gilt, and bejeweled, it must have seemed like the three-dimensional embodiment of an Eyckian painting (see fig. 9). Even in its present state, it remains a masterful example of the sculptor's art.

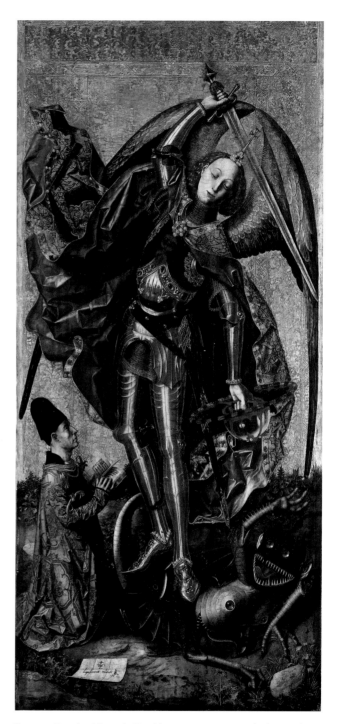

FIGURE 9. Bartolomé Bermejo (Spanish, 1435–1495). *Saint Michael Triumphant*, 1468. Oil on panel; 179.7 x 81.9 cm (70 ¾ x 32 ¼ in.). National Gallery, London, NG6553.

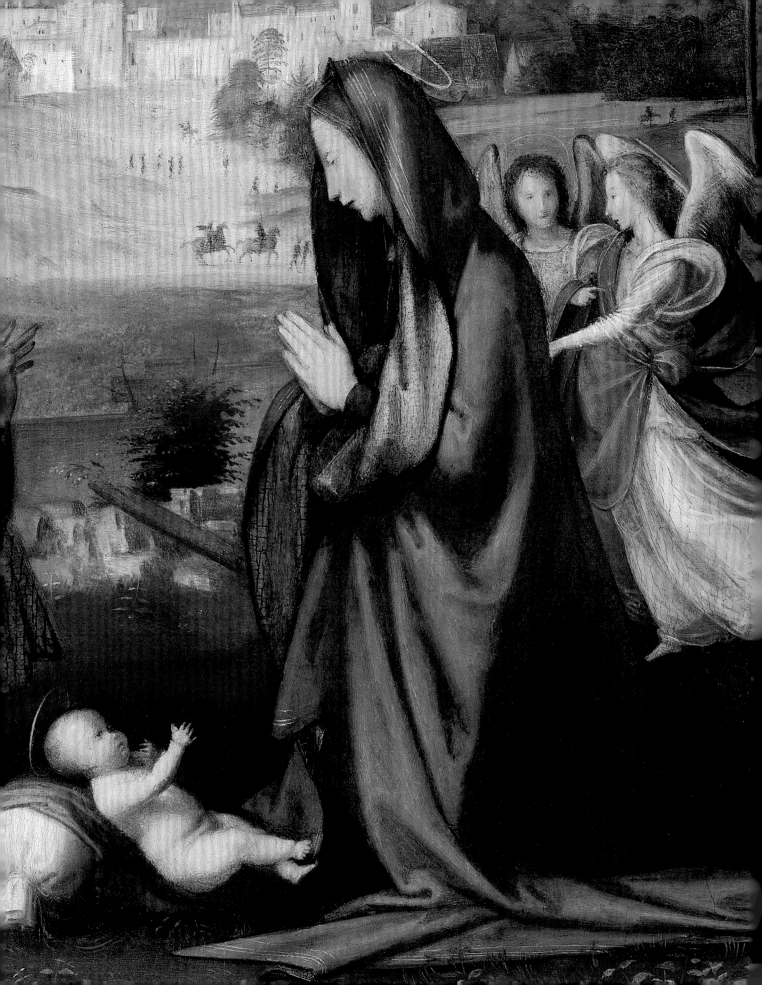

Fra Bartolommeo's Nativity: A Rediscovered High Renaissance Masterpiece

LARRY J. FEINBERG

Patrick G. and Shirley W. Ryan Curator in the Department of Medieval to Modern European Painting and Sculpture

OPPOSITE: Detail of *The Nativity* (fig. 1).

Before its rediscovery in 2001, this precious Nativity (opposite and fig. 1) by the High Renaissance master Fra Bartolommeo (born Baccio della Porta) had been known for hundreds of years only from brief, sixteenth-century references and words of praise. But those scant records accorded the picture, despite its modest size, a measure of importance— noting its value as a hefty thirty gold *ducats* or *florins* and reporting that the "very beautiful" painting had been sent to France.[1] True to the descriptions, this is one of the artist's more carefully conceived and exquisitely crafted works, a seemingly effortless assimilation and very personal transformation of elements that he observed in the paintings of his exalted contemporaries Sandro Botticelli, Leonardo da Vinci, and Raphael Sanzio. Moreover, in style and detail, he seems to have subtly designed *The Nativity* to please the tastes of a discriminating French patron.

After some initial training with two of Florence's most conservative fifteenth-century painters, Cosimo Rosselli and Domenico Ghirlandaio, the young Baccio della Porta found himself much intrigued by the artistic innovations of Leonardo. He studied Leonardo's paintings very carefully, emulating the master's novel, smoky atmospheric effects (*sfumato*) and mobility of light but avoiding his complexities of composition and pose. Probably due to the old-fashioned instruction Baccio had received as well as his own inclinations toward restraint, he seems to have preferred simple statement with minimal narrative. Accordingly, his mature works are marked by a clear geometry and balanced calm, as the circumspect painter shied from the boldness and dynamism of the art of Leonardo, Raphael, and Michelangelo, relegating any extremely lively or undisciplined activities to the extensive background landscapes of his pictures. Leonardo may have spurred this strong interest in natural topography, which was highly unusual for Florentine painters of the early sixteenth century.

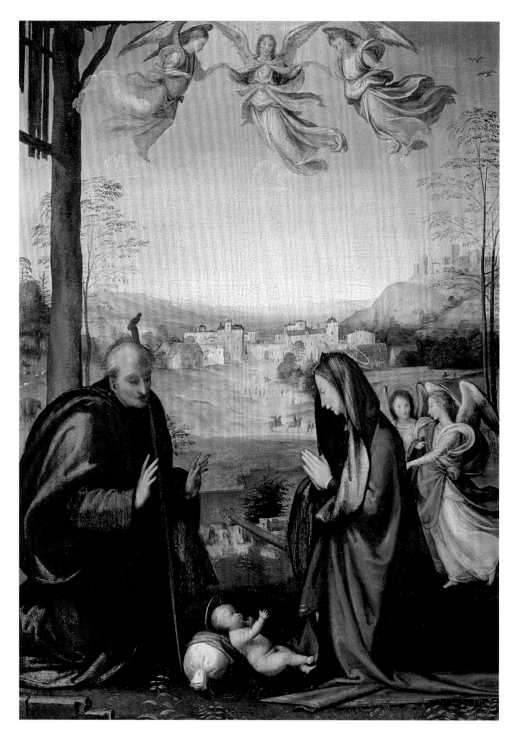

FIGURE 1. Baccio della Porta, called
Fra Bartolommeo (Italian, 1472–
1517). *The Nativity*, 1504/07. Oil on
panel; 34 x 24.5 cm (13 ⅛ x 9 ⅝ in.).
Ethel T. Scarborough Fund; L. L. &
A. S. Coburn, Dr. and Mrs. William
Gilligan, Mr. and Mrs. Lester King,
John and Josephine Louis, Samuel
A. Marx, Alexander McKay,
Chester D. Tripp, and Murray Vale
endowment funds; restricted gift
of Marilynn Alsdorf, Anne Searle
Bent, David and Celia Hilliard,
Alexandra and John Nichols, Mrs.
Harold T. Martin, Mrs. George B.
Young in memory of her husband;
the Rhoades Foundation; gift of
John Bross and members of the
Old Masters Society in memory
of Louise Smith Bross; through
prior gift of the George F. Harding,
Mr. and Mrs. W. W. Kimball, Mr.
and Mrs. Martin A. Ryerson,
and Charles H. and Mary F. S.
Worcester collections, 2005.49.

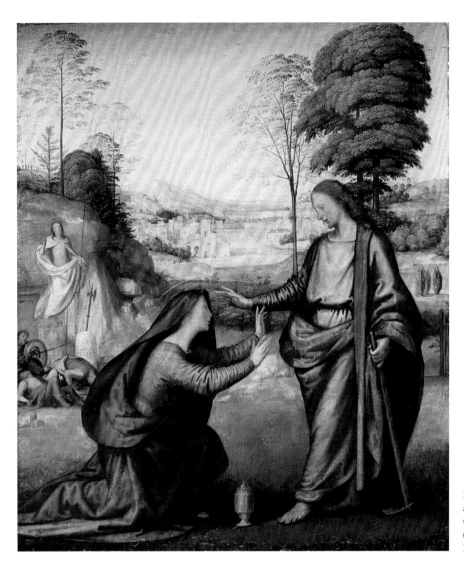

FIGURE 2. Fra Bartolommeo. *Noli me tangere*, c. 1506. Oil on canvas, transferred from panel; 57 x 48 cm (22 ¹/₂ x 19 in.). Musée du Louvre, Paris, 39.

The Nativity was almost certainly executed in the period in which Baccio resumed his artistic career, after having joined the Dominican order as Fra (Friar) Bartolommeo and having put aside his brushes for some four years (between 1500 and 1504).[2] From a ledger maintained in the Florentine monastery of San Marco, where the painter was cloistered, it is known that the picture was purchased by a certain Domenico Perini on April 16, 1507, and exported to France, along with a *Noli me tangere* (fig. 2) that Fra Bartolommeo had created around 1506.[3] The disparity in the scale of the two works—the *Noli me tangere* is almost twice as large— suggests that the artist did not intend them as companions.[4] There are, nonetheless, close stylistic similarities between the two paintings in the attenuated elegance of the figures,

refined profiles, tenuous pointed gestures, and extensive landscapes—elements that would have appealed to contemporary French and northern European sensibilities. Indeed, in the late fifteenth and early sixteenth centuries, the prevailing flavor of Northern art remained Gothic, with the principal artistic models being elongated cathedral jamb figures; the sprightly, insubstantial hunters and woodsmen that animated the luxurious landscapes of tapestries; and the fragile, slender actors that populated some of the paintings and manuscript illuminations of artists such as Jean Fouquet and Jean Bourdichon.[5]

Relatively conservative in thought and approach, Fra Bartolommeo has presented the Nativity in a traditional, if especially intimate, manner: the humbly kneeling Virgin,

hands in prayer, gazes reverently at the Christ Child, while Joseph's pose is one of mild surprise or wonderment, suggesting a sudden revelation of the infant's divine nature. The Holy Family finds shelter in a rustic stall, which, as remnants of masonry in the mid- and foreground indicate, was erected within the ruins of an ancient edifice. A common motif in Italian Renaissance painting, this juxtaposition symbolizes Christ's establishment of his new church on the Old Testament order, or Old Dispensation, of the Jews. Just within the masonry walls, at the center of the composition and directly above the infant, is an outcropping of age-old rock from which a young tree springs forth with several new shoots and branches. Having appropriated this metaphorical device from Leonardo's celebrated, unfinished *Adoration of the Magi* (1481; Galleria degli Uffizi, Florence), Fra Bartolommeo compounded its meaning by placing a piece of wood upon the rocks, an obvious allusion to Christ's cross on Golgotha.[6] Lest the viewer overlook these symbols, the two angels at right point to, and presumably discuss, their implications.

All of this is observed by a trio of angels above, who, unconventionally, join hands in a manner reminiscent of the classical Three Graces. However, the source of this lyrical arrangement is probably not antique, but contemporary—Botticelli's idiosyncratic *Mystic Nativity* (fig. 3), in which a triad of angels kneel on the crèche, while others hold hands as they glide airborne in a circle.[7] Inspired by the apocalyptic sermons of the controversial Dominican friar Girolamo Savonarola (who was burned at the stake for heresy in 1498), *The Mystic Nativity* would have been eagerly consulted by Fra Bartolommeo, whose own admiration for the friar led, in fact, to his taking the vows of the same order.[8] Examination of an X-radiograph of the Chicago *Nativity* (fig. 16) reveals sinuous lines of underpaint that may

FIGURE 3. Sandro Botticelli (Italian, 1445–1510). *The Mystic Nativity*, 1500/01. Oil on canvas; 108.6 x 74.9 cm (42 3/4 x 29 1/2 in.). National Gallery, London, NG1034.

FIGURE 4. Detail of falconers in *The Nativity* (fig. 1).

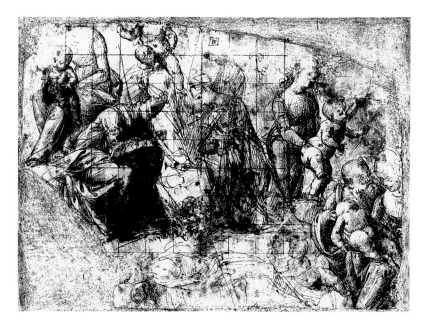

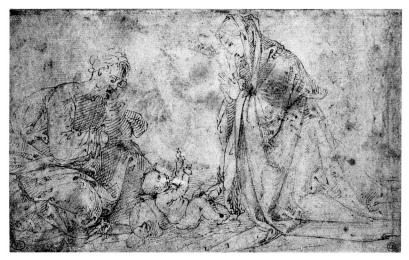

FIGURE 5. Fra Bartolommeo. *Studies for a Nativity*, 1504/07. Pen and ink; 19.5 x 26 cm (7 11/16 x 10 1/4 in.). Gabinetto Disegni e Stampe, Galleria degli Uffizi, Florence, 1244E.

FIGURE 6. Fra Bartolommeo. *Study for a Nativity*, 1504/07. Pen and ink; 9.8 x 16.3 cm (3 7/8 x 6 3/8 in.). Musée du Louvre, Paris, RF5554.

have been ribbons or banderoles, suggesting that Fra Bartolommeo first painted his trinity of angels in a fashion similar to Botticelli's flying group, who are adorned with streaming ribbons inscribed with verses praising God and the Virgin.[9] As we shall see, this would have been only one of myriad adjustments that the artist made as he worked up the composition.

Watching the hovering angels is, at upper right, a pair of large birds which, by their broad, brown wingspans and white underbodies, can be readily identified as falcons.[10] They undoubtedly belong to the hunting party represented in the middle and right distance, proceeding toward the woods for game. As was typical for such recreation, a master falconer rides on horseback, while his minions—underfalconers, falconry valets, undervalets, and bird netters—accompany him on foot. These assistants usually carried long poles, barely discernible here, in order to flush prey out of trees and bushes (see fig. 4). The artist also rendered, on a microscopic scale, a mounted falconer with what appears to be a bird perched on his arm. In a common technique known as a *cast*, a pair of birds has been sent out together to survey the forest, while the falconers follow.[11] Amusingly, the birds have seemingly circled back from their course to look at the angels, a distraction that, when caused by ordinary winged creatures, is called by falconers a *cheque*.[12]

Fra Bartolommeo may have included the falconry scene for reasons other than merely providing a slice-of-life anecdote. If he painted the work with a French patron in mind, particularly a noble or royal one, he would have known that such details would be well appreciated. In the sixteenth century, Italians associated falconry with the French aristocracy, who did not invent the sport but in many ways codified and perfected it.[13] Indeed, the very extensive and precise terminology of falconry, which concerns the movements, physical attributes, care and training, and even bodily functions of the

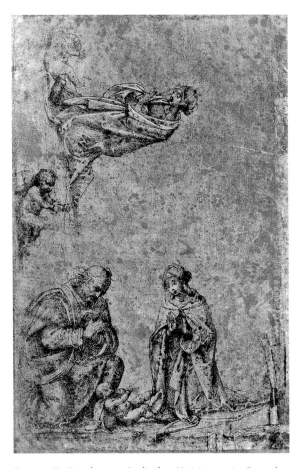

FIGURE 7. Fra Bartolommeo. *Studies for a Nativity*, 1504/07. Pen and ink; 23.5 x 15.8 cm (9 ¼ x 6 ¼ in.). Gabinetto Disegni e Stampe, Galleria degli Uffizi, Florence, 1203E.

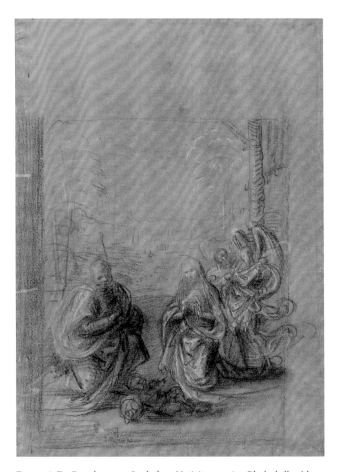

FIGURE 8. Fra Bartolommeo. *Study for a Nativity*, 1504/07. Black chalk with white heightening; 18.9 x 21.1 cm (7 ⁷/₁₆ x 8 ⁵/₁₆ in.). Museum Boijmans Van Beuningen, Rotterdam, 1563M96.

birds, was developed in France, from where it spread to Italy. An expensive pastime, this form of hunting had always been a privilege of the nobility, and, in the early fifteenth century, King Charles VI of France published a decree officially limiting its practice to the highest classes. In light of the fact that Fra Bartolommeo's earlier *Noli me tangere* was sold to Louis XII, it is probable that *The Nativity* also had a royal, or at least highly distinguished, patron.

Like Leonardo, who took pleasure in contrasting physical types and activities in his pictures, Fra Bartolommeo sometimes offered interesting oppositions; in this case he compared the aristocratic, avian pastimes of some to the mundane vocation of the shepherds in the left background. He also juxtaposed the modest, thatched cottages of these rural folk with the impressive towers and other stone structures from which the falconers presumably come. These contrasts serve to underscore the ironic situation of

the Holy Family: divine sovereigns attended by a heavenly entourage but kneeling or lying on the ground in attitudes of utmost humility.

Fra Bartolommeo arrived at this touching portrayal of the Nativity only after undertaking what must have been a long and circuitous design process. Before he made the aforementioned changes at the painting stage, he prepared and elaborated many drawings of individual figures, figural groups, the landscape, and the overall composition. Following the procedures of Leonardo and Raphael, Fra Bartolommeo would have begun by experimenting with various subjects and attitudes for the Holy Family on what has been described as a "brainstorming" sheet.[14] In the middle of just such a sheet, preserved in the Uffizi (fig. 5), is a depiction of the Holy Family that appears to be the germ of the Chicago and other, related compositions. The artist squared the page in order to transfer the various designs

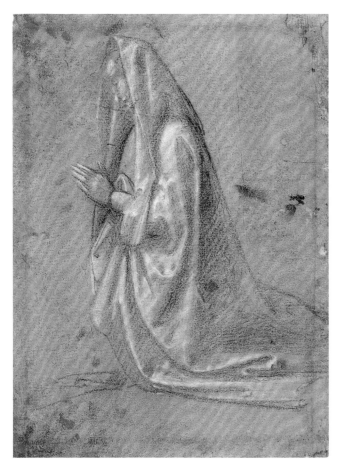

FIGURE 9 (at top left). Fra Bartolommeo. *Study of the Virgin*, 1504/07. Black chalk with white heightening; 28 x 20.6 cm (11 x 8 1/8 in.). Museum Boijmans Van Beuningen, Rotterdam, 1563N88.

FIGURE 10 (at left). Fra Bartolommeo. *Study for a Nativity*, 1504/07. Black chalk; 30 x 20.5 cm (11 13/16 x 8 1/16 in.). Gabinetto Disegni e Stampe, Galleria degli Uffizi, Florence, 230.

FIGURE 11 (at top right). Fra Bartolommeo. *Studies for a Nativity*, 1504/07. Pen and ink; 22.5 x 15.5 cm (8 7/8 x 6 1/8 in.). Musée du Louvre, Paris, 203.

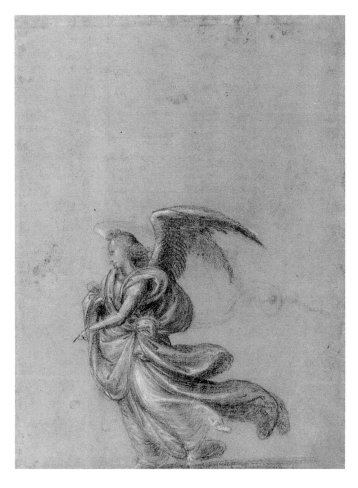

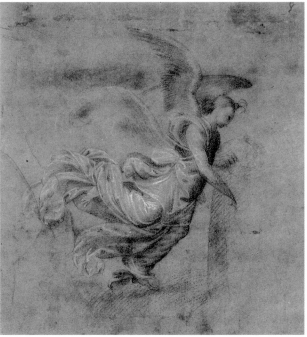

more easily to other sheets for use and revision.[15] From the central study, which presents the Virgin in profile and Saint Joseph huddled closely to the child (on the ground, summarily indicated), he seems to have developed the figural group in a pen-and-ink sketch in the Musée du Louvre (fig. 6) and then, repositioning the Virgin, in the drawing of the Holy Family on the lower part of another sheet in the Uffizi (fig. 7).[16] Consulting the latter sketch, Fra Bartolommeo subsequently created an evocative, chiaroscuro study in Rotterdam (fig. 8). In the end, he decided to render the Virgin in profile; to determine her exact orientation and especially to design her drapery, he posed a model in the studio (see fig. 9).

Several other sheets indicate Fra Bartolommeo's further improvisation on the arrangement and number of figures for the Chicago picture and, no doubt, other works as well. A rough, black chalk sketch in the Uffizi (fig. 10) reveals that the artist, at one point, had the idea of placing the Christ Child on Joseph's lap. At right, he also very tentatively suggested the presence of two angels witnessing this unusual, tender, familial exchange. On the upper half of another sheet in the Louvre (fig. 11), he transferred the infant to the Virgin's lap and clearly demarcated the pair of angels.[17] The angels reappear in two, more resolved compositional drawings—one in which an angel holds the Christ Child before the Virgin (1506/08; Galleria degli Uffizi, Florence) and another in which the young Saint John the Baptist is present while the standing angels interact with a third infant (1506/08; Musée du Louvre, Paris).[18] The artist either consulted some of these sheets or looked at other studies, now lost, when conceiving the standing angels of the chiaroscuro study (fig. 8) and the Art Institute's painting. In any case, he eventually decided to render the angel in profile with a pointing gesture (see fig. 12). Also in Rotterdam is a drawing for the flying angel at upper left, similarly realized in black chalk with white heightening (fig. 13).

FIGURE 12. Fra Bartolommeo. *Study of an Angel*, 1504/07. Black chalk with white heightening; 28.4 x 21.7 cm (11 3/16 x 8 1/2 in.). Museum Boijmans Van Beuningen, Rotterdam, 1563M74.

FIGURE 13. Fra Bartolommeo. *Study of an Angel*, 1504/07. Black chalk with white heightening; 20.9 x 20.3 cm (8 1/4 x 8 in.). Museum Boijmans Van Beuningen, Rotterdam, 1563M112a.

FIGURE 14. Fra Bartolommeo. *Landscape Study*, 1504/07. Pen and ink; 13.3 x 20.5 cm (5 1/4 x 8 1/16 in.). Musée du Louvre, Paris, 18645.

FIGURE 15 (below). Fra Bartolommeo. *Landscape Study*, 1506/07. Pen and ink; 27.9 x 21.8 cm (11 x 8 1/8 in.). Metropolitan Museum of Art, New York, 57.165.

For the landscape of the Chicago *Nativity*, Fra Bartolommeo, who shared Leonardo's passion for the natural world, turned to his file of drawings and found a particularly lovely panoramic view he had drawn *en plein air* in the Tuscan countryside (fig. 14). He revised this rural townscape slightly in a later sheet (fig. 15), adding an elegant coulisse of trees and, at right, a grand tower—a transalpine touch inspired by an edifice that he copied from a print by Albrecht Dürer.[19] The framing trees provided reference points as he inserted the landscape into his composition, as seen in both the large chiaroscuro study (fig. 8) and the painting itself.

As noted earlier, Fra Bartolommeo's complex design process did not end with drawings but continued after he laid brush to panel. Many changes at the paint stage are revealed in the X-radiograph of the work, the most significant being the reduction in the scale of the angels (see fig. 16).[20] The artist had at first rendered them, as in a few of the drawings (see fig. 11), as comparable in size and stature to the Virgin and Saint Joseph. In the painting, presumably to focus more attention on the Holy Family, he reduced the angels, placing them more in the distance. For similar reasons, he may have eliminated the fluttering ribbons from the three hovering angels, perhaps feeling that too

FIGURE 16. X-radiograph of *The Nativity* (fig. 1), which suggests how Fra Bartolommeo reduced the size of the standing angels, eliminated the fluttering ribbons of their airborne companions, and adjusted the poses of the Holy Family.

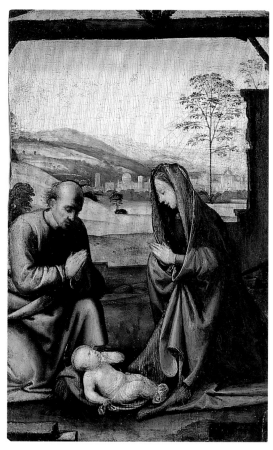

FIGURE 17. Fra Bartolommeo. *The Holy Family*, c. 1504/07. Oil on panel; 14.1 x 9.2 cm (5 9/16 x 3 5/8 in.). Speed Art Museum, Louisville, Museum purchase with additional funds from Friends, 1976.31.

FIGURE 18. Fra Bartolommeo. *The Holy Family with Infant Saint John*, c. 1506/07. Oil on panel; 62 x 47 cm (24 3/8 x 18 1/2 in.). Museo Thyssen-Bornemisza, Madrid

much detail distracted the viewer from the central figures. He also discreetly adjusted the poses of the Holy Family: the X-ray indicates that Mary was originally placed slightly closer to her son, her head cast a bit more downward. The position of the infant has been altered as well: he has been moved to the right so that his head is not quite so high on the sack (used as a pillow), and he has been made smaller, more delicate and vulnerable.

Some of the figural poses and compositional arrangements that Fra Bartolommeo elaborated in drawings, but chose not to employ in the Art Institute's *Nativity*, can be found in two other, closely related and contemporary paintings of the same subject now in the Speed Art Museum in Louisville, Kentucky, and the Museo Thyssen-Bornemisza, Madrid (figs. 17–18).[21] The chronology of these pictures, particularly in respect to the Chicago *Nativity*, is difficult to determine. But it may be that Fra Bartolommeo

availed himself of the Chicago work, into which he seems to have put a special, concentrated effort, when creating these other versions. The Louisville painting, very likely once part of a diptych with a Crucifixion (now Martin Peretz Collection, Cambridge, Mass.), appears to be a simplified revision of the Chicago composition, lacking many details and the delicacy of touch.[22] In the Madrid work, the artist introduced a toddler Saint John at right, with the result of diminishing the serene and harmonious effects that he had learned from Leonardo and Raphael and which characterize the Chicago picture and many of his mature productions. Indeed, in this respect the Art Institute's *Nativity* typifies the calm, gentle, and deeply pious spirit of Fra Bartolommeo's most accomplished pictures and epitomizes the distinctive artistic personality of this highly gifted, if historically overshadowed, painter.

Much of Real Fascination: New Discoveries among the Italian Baroque Drawings in the Art Institute of Chicago

Nicholas Turner

Opposite: Detail of *An Artist's Studio during an Earthquake* (fig. 20).

The Art Institute of Chicago's fine collection of seventeenth-century Italian drawings remains comparatively little known, with the result that the occasional new discovery can still be made.[1] Such finds are a species of new acquisition, since under a revised and more convincing attribution they are in effect novelties to the collection. The significant difference between them and new acquisitions made by purchase, however, is that they cost absolutely nothing!

The purpose of this article is to revive interest in the Art Institute's holdings of such works by highlighting some previously unidentified examples by a number of the more important artists of the time. It is perhaps worth reiterating here that the museum's Italian Baroque drawings come from two principal sources: the gift in 1922 of the geologist William F. E. Gurley and the bequest in 1927 of the industrialist Charles Deering. Over 6,800 in number, the Gurley drawings have long been regarded as something of a mixed blessing. In 1947, for example, the Viennese art historian Hans Tietze observed too harshly that they contained "little of real fascination: a case of too much and too little."[2] With recent increased knowledge of Italian drawings, however, the Gurley collection continues to yield up more and more treasures. On the other hand, Deering's gift of Old Master drawings was much smaller, though relatively speaking is of higher quality.[3] Since World War II, further important acquisitions in this field have continued to be made, by both gift and purchase, right up until the present day.

When the first so-called new discovery (see fig. 1) entered the Art Institute with the Gurley collection, it was attributed to Guido Reni; but on account of it being a carefully finished drawing of the sort that is today quite out of fashion, it was long ago demoted to his school and has remained unpublished.[4] Reni was the leading painter of the seventeenth-

FIGURE 1. Guido Reni
(Italian, 1575–1642). *Modello for
"The Pentecost,"* 1608. Pen and
brown ink with brush and brown
wash, heightened with gold paint,
with traces of brush and red wash,
over black chalk, squared in black
chalk, on brown laid paper; 33.9 x
37.2 cm (13 ³/₈ x 14 ⁵/₈ in.). Leonora
Hall Gurley Memorial Collection,
1922.3159.

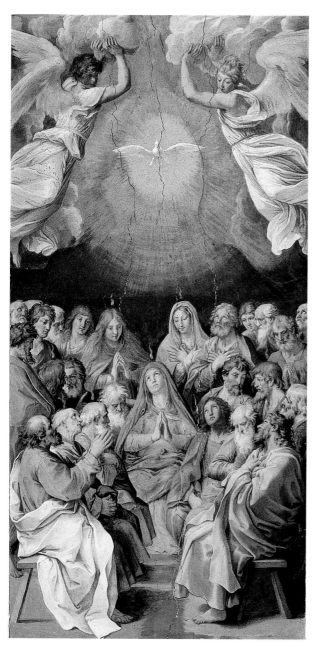

FIGURE 2. Guido Reni. *The Pentecost*, 1608. Fresco; 373 x 182 cm (146 7/8 x 71 5/8 in.). Sala delle Dame, Palazzo Vaticano, Rome.

FIGURE 3. Detail of *Modello for "The Pentecost"* (fig. 1), showing heads and hands of apostles on the left side of the composition.

FIGURE 4. Detail of *The Pentecost* (fig. 2), showing the same area.

FIGURE 5. Guido Reni. *Study for "The Pentecost,"* 1608. Pen and brown ink, with brown wash, over black chalk; 23.5 x 15.6 cm (9 1/4 x 6 1/8 in.). Private collection.

century Bolognese School. He trained under the Flemish painter and draftsman Denys Calvaert and then under the Carracci family, and by the mid-1590s was successful enough to set himself up as an independent master, transferring to Rome soon after 1600. Following a brief flirtation with Caravaggism he perfected his cool, supremely stylish neo-Raphaelitism, establishing himself in the process as a great master. Soon after the election in 1605 of Cardinal Camillo Borghese as Pope Paul V (1605–21), Reni became the favorite painter of both the pope and his powerful nephew, Cardinal Scipione Borghese.

The Art Institute's drawing is a fragment of Reni's finished compositional study for *The Pentecost* (or *Descent of the Holy Spirit*), a ceiling fresco in the central *quadro riportato*—literally a "transferred picture" (i.e. a canvas or

fresco inserted into a ceiling decoration)—of the Sala delle Dame, a room not far from the Sistine Chapel in the Vatican (fig. 2). Within the same elaborate stucco frame, to either side of the central compartment, the artist painted two smaller roundels, *The Transfiguration* and *The Ascension.*[5] The Chicago sheet appears to be Reni's only surviving drawn *modello*. Exquisitely handled in pen and wash, with the facial features of the figures beautifully modeled, it was surely made for the presentation of the project to the patron. As it survives today, it is unfortunately in rather poor condition and includes only the lower half of the composition; at one time it would have extended upward to show the top half of the design, with two magnificent winged angels separating the clouds to give passage to the Holy Spirit.

Reni executed his Pentecost fresco for Paul V in 1608 on the commission of Cardinal Borghese. With the drawing's presentational purpose in mind, it is understandable that the artist should have invested so much time in its realization. Intact and in its prime, it must have been spectacular—Reni delicately touched in the highlights in gold (rather than in cheaper, plain white); picked out some areas with occasional touches of color, remnants of which can still be seen; and executed the whole with a miniaturist's attention to detail. Under close examination, the line work is tough and assured, as well as consistent in style with Reni's freer, more characteristic pen-and-wash drawings.

It has been wrongly claimed in the past that the Chicago drawing is a copy after Reni's Vatican fresco.[6] Detail for detail, however, the position of the figures in certain passages is fundamentally different from that of their counterparts in the painting. Most significantly, perhaps, the beardless Saint John, seated to the right in the drawing, appears adjacent to the Virgin in the fresco, while a bearded apostle takes his place on the stool in the lower-right corner. The heads and shoulders of the four apostles seated in the left foreground of the composition are much the same in both works, but at some point the artist decided to simplify the grouping by omitting the crossed hands of the apostle to the left of the Virgin (see figs. 3–4). Moreover, in the drawing, the heads of the apostles and some of their companions at the back are only slightly higher than the Virgin's, while in the fresco they are raised up more, as if the lower ranking apostles—like participants in a group photograph—had to stand on a platform behind. Finally, the squaring for transfer bears out the other, internal evidence just considered, namely that the drawing was, for

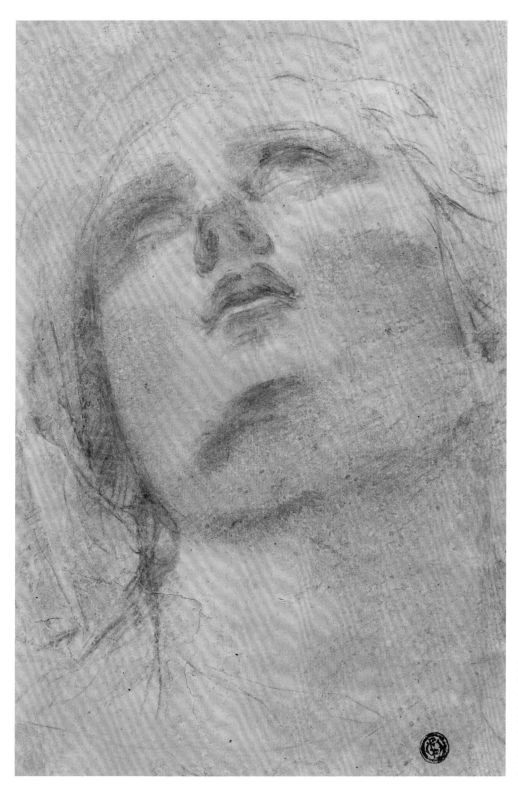

FIGURE 6. Giovanni Lanfranco (Italian, 1582–1647). *Study for the Head of the Virgin in "The Assumption of the Virgin,"* 1615. Black chalk heightened with white chalk on brown laid paper; 25.5 x 17.3 cm (10 ¹/₁₆ x 6 ³/₁₆ in.). Leonora Hall Gurley Memorial Collection, 1922.528.

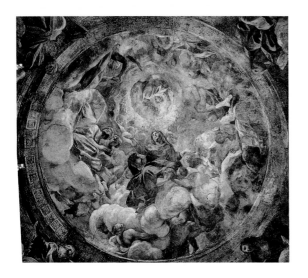

FIGURE 7 (at top left). Giovanni Lanfranco. *The Assumption of the Virgin*, 1615. Fresco. Cupola, Buongiovanni Chapel, Chiesa di San Agostino, Rome.

FIGURE 8 (at top right). Detail of *The Assumption of the Virgin* (fig. 7), showing the head of the Virgin.

FIGURE 9 (above). Giovanni Lanfranco. *Study for the Figure of the Virgin in "The Assumption of the Virgin,"* 1615. Black chalk and gouache on gray paper; 50.9 x 36.3 cm (20 x 14 ¼ in.). Musée du Louvre, Paris, 6316 r.

Reni, a stepping stone in the sequence of ideas leading to the painted result, not a copy made by another hand after the fresco was completed.

Comparison between the Art Institute's *modello* and Reni's unpublished, early compositional drawing (fig. 5) for the Pentecost fresco is also illuminating.[7] The significant role that Borghese played in the commission seems to be signaled in the rapidly drawn study, in which the artist included a half-length donor portrait, presumably of the cardinal, at the lower center, with a detailed alternative study of his nose and lips at the upper right. Reni made substantial changes as he progressed from this drawing, which reflects the germ of his invention, to the *modello*, to the finished fresco. For instance, he abandoned the donor figure by the time of the *modello*, just as he did the gesture of the Virgin, who lifts up her hands as if to receive the Holy Spirit. (Interestingly, he adopted this memorable position for the figure of Christ in his little roundel of the Ascension). In the final fresco, the Virgin is moved down a tier so that she occupies a central position surrounded by the other praying and astounded figures. Instead of including only the twelve apostles, as in the drawing, the artist increased the group to include Mary Magdalene and twelve additional figures representing the twelve nations of the world, each of whom heard its own language spoken (Acts 2:6).

The black chalk *Study for the Head of the Virgin* by Giovanni Lanfranco (fig. 6) is another interesting, previously undiscovered drawing from Gurley's donation.[8] This went unnoticed in the collection largely on account of its being wrongly attributed, traditionally to the Marchigian Federico Barocci, well known for his accomplishment

in chalk drawing, and subsequently to the Bolognese Giacomo Cavedone, another, later draftsman who made many drawings in charcoal and black chalk. Lanfranco, who was born in Parma, self-consciously set himself the task of continuing the great tradition of Parmese painting established by Antonio Correggio. He first trained under Agostino Carracci in Parma, and, following his death, became a pupil in Rome of Agostino's brother Annibale. During the second and third decades of the seventeenth century in Rome, Lanfranco was the bitter rival of Domenichino, the two painters often vying against each other for the most prestigious commissions of the day. He is perhaps best known for a number of illusionistic dome frescoes painted in the style of Correggio, which he carried out in Rome and Naples during his middle and late career; the most famous of these (1625–27) is in the Church of San Andrea della Valle, Rome.

The soft, painterly handling of the Art Institute's work is certainly Correggesque but is filtered by the more up-to-date graphic style of such painters as Annibale Carracci and Guido Reni. The drawing is a study, with some modifications, for the Virgin in Lanfranco's earliest cupola fresco, *The Coronation of the Virgin*, painted in 1615 for the Buongiovanni Chapel in San Agostino, Rome (figs. 7–8).[9] The pictorial decoration of the chapel, including the ceiling, was the artist's first major independent public commission in Rome, and its success established him as a rival to Domenichino. His sketch for the full-length figure of the Virgin (fig. 9), also in black chalk, shows two pentiments for her head, the second of which corresponds exactly with its position in the Art Institute's sheet.[10]

Study for the Head of the Virgin appears to be unique in Lanfranco's surviving oeuvre, since he is not known to have made any other similar head studies in chalk. The drawing may possibly have served as an auxiliary cartoon— that is, a finished study produced at the last stage of the preparatory process, with the outlines often traced from the full-size cartoon and thus made to the same size as the corresponding detail to be painted. Artists created such works as a matter of routine in the Italian Renaissance, but the more liberated studio practice of the Baroque period saw a downturn in their production. Nevertheless, detail studies of heads for the more important figures in a given painting, not always necessarily corresponding exactly in size to their painted counterparts, continued to be made in the seventeenth century, especially by painters of the Bolognese School, including Reni, the Carraccis, and

others. Even if Lanfranco did not continue using such studies in his later work, it is surely not surprising that he made this drawing, which is for the most important figure in a commission that promised to make his reputation.

Another Bolognese painter, who strove with great determination throughout his life to outstrip his archrival, Reni, was Giovanni Francesco Barbieri, called Guercino. Without a doubt one of the most accomplished draftsmen of the Baroque period in Italy, he was born at Cento in Emilia, where he spent much of his career, apart from a short period in Rome from 1621 to 1623. In 1642, shortly after Reni's death, he moved to Bologna to take up the mantle of the city's leading painter of the day and remained there until his own death twenty-four years later. Guercino's drawings are exceptionally lively and spirited, and have long been admired for these qualities. The great eighteenth-century French connoisseur Pierre-Jean Mariette aptly characterized them as having "a charm that one does not find in the drawings of any other master."[11] So prolific an artist was Guercino and so profoundly did his style change—both as a painter and draftsman—over a career lasting more than fifty years, that some of his more unusual drawings sometimes still resist appropriate classification.

A fascinating double-sided sheet—yet another of the Gurley drawings—with a compositional study of *Abraham's Sacrifice* on the front (fig. 10) and *Jacob's Dream* on the back (fig. 11) was formerly placed as "School of Guercino," although it is unquestionably a study by the master himself. Done while he was still in his twenties, at the very outset of his activity, there can be little doubt that it is the earliest in date of the fine group of drawings by Guercino belonging to the Art Institute.[12] Here, the delicate, calligraphic quality of both images shows the influence of Ludovico Carracci, the great *caposcuola* who directed the Carracci Academy in Bologna during the first two decades of the seventeenth century and trained many of the city's next generation of painters, among them Cavedone. There is even possibly a direct compositional dependence between Guercino's *Abraham's Sacrifice* and Carracci's early painting of the subject (1586/87; Pinacoteca Vaticana), then probably in Bologna.[13] Unfortunately, the precise purpose of the two studies on the Chicago sheet remains to be established, and it would be idle to speculate here on what this might have been. Nevertheless, both drawings represent Old Testament subjects, share the same horizontal format, and were conceived *en serie*, either as pendants to each other or as part of a larger sequence of such representations.

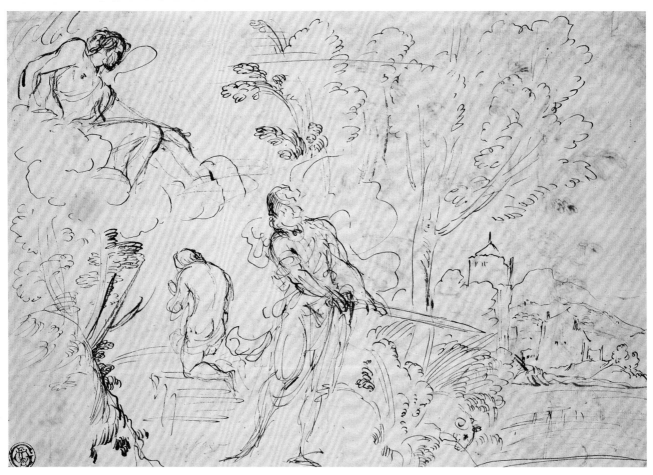

FIGURES 10–11. Giovanni Francesco Barbieri, called Guercino (Italian, 1591–1666). *Abraham's Sacrifice* (recto) and *Jacob's Dream* (verso), c. 1615. Pen and brown ink, on ivory laid paper; 17.3 x 25.5 cm (6 ¹³⁄₁₆ x 10 ¹⁄₁₆ in.). Leonora Hall Gurley Memorial Collection, 1922.248.

What makes this early Guercino drawing unusual, however, and must have given others doubts about his authorship, is the lack of any reinforcing passages of brown wash, which, in his early work, the young artist invariably applied as an accompaniment to his pen drawing. There are, however, some other instances of pen drawings by Guercino without any wash. One of them is *Sheet of Studies for "Saint William of Aquitaine Taking the Habit,"* on loan to the Ashmolean Museum, Oxford (fig. 12).[14] Apart from the general similarity in the tempo of the line between the Chicago and Oxford drawings, there are some quite specific parallels of detail. These include the foreshortened head of the young Jacob asleep on the ground, seen on the verso of the Chicago sheet, and the foreshortened head of the acolyte looking up, seen over the right shoulder of the kneeling Saint William, in the principal study in the drawing at Oxford.

Another of Guercino's drawings—and the first work we have discussed to have come from the Deering bequest— is a study of *Satan Fallen to the Ground* (fig. 13); in spite of the prominent old inscription *Del Guercino* at the bottom of the sheet, the attribution seems not to have been accepted in recent years.[15] Done much later in the artist's career than the previous study, probably in the 1640s, this gives the appearance of having been made as a life drawing in its own right, with the model cast as the devil to add character to the exercise. There are good reasons for thinking, however, that it may be an early study for the figure of Satan in Guercino's altarpiece *Saint Michael the Archangel* (fig. 14) in San Nicola at Fabriano, commissioned in 1644 by Signor Pinto Fattorelli of that city.[16] Although the painted devil is posed very differently from the drawn figure, both have a mop of curly black hair and a wispy, military-style

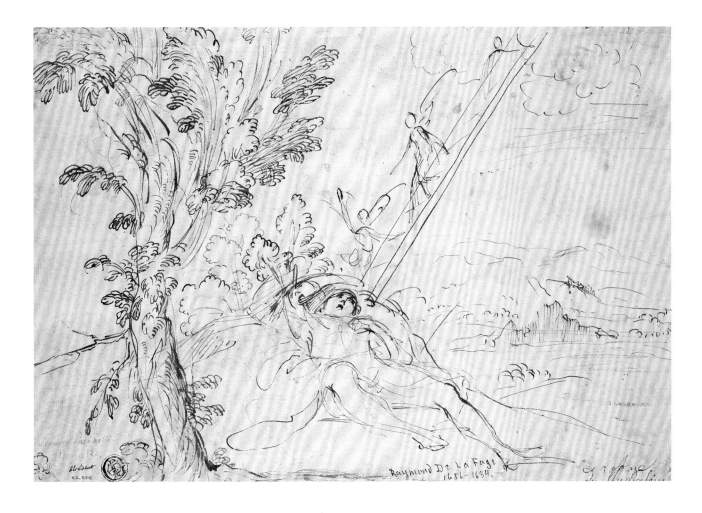

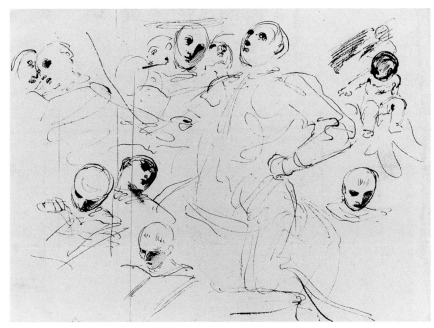

FIGURE 12. Guercino. *Sheet of Studies for "Saint William of Aquitaine Taking the Habit,"* 1620. Pen and ink, on paper; 19.6 x 27 cm (7 ³/₄ x 10 ¹/₈ in.). Ashmolean Museum, Oxford, on loan from the collection of Sir Denis Mahon.

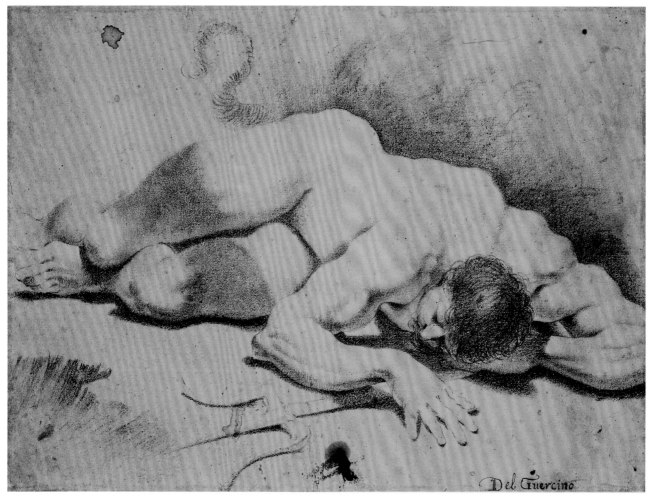

FIGURE 13. Guercino. *Satan Fallen to the Ground*, 1635/40. Oiled charcoal, on gray-brown laid paper; 41.1 x 56.9 cm (16 ¹/₈ x 22 ³/₈ in.). Charles Deering Collection, 1927.7702.

moustache, and both are on the point of falling over a cliffy bank into an inferno. More in favor of the connection, perhaps, is the presence of a curly, reptilian tail—long and thick in the painting but so short and modest in the drawing that it is easily mistaken for one of the flames licking at the devil's back.

Powerful by any definition, this work was done in oiled charcoal on gray-brown paper, the same materials that Guercino habitually employed in his early studies of the male nude. *Satan Fallen to the Ground* seems a more typical example of the artist's style than the previous sheet, and, indeed, the handling finds good parallels in his other drawings, both early oiled charcoal studies of nudes done about 1620 and occasional studies, sometimes in a combination of oiled charcoal and black chalk, from

around the 1630s and 1640s.[17] The figure of Satan seems to have been inspired by that of the devil in Reni's famous altarpiece *Saint Michael the Archangel*, painted in 1635 for one of the altars of Santa Maria della Concezione, Rome. Perhaps it was this very proximity to Reni's prototype that persuaded Guercino to change the figure in the painting.[18]

Another large-scale drawing by Guercino from the Deering bequest, *Modello for "The Flagellation of Christ"* (fig. 15), is a finished study for his large altarpiece—painted in 1644, the very same year as his altarpiece in Fabriano—for San Biagio, Vicenza, now in the Museum of Fine Arts, Budapest (fig. 16).[19] So familiar are we with Guercino's more habitual, rapid pen-and-wash sketches that this carefully completed study strikes an unfamiliar note: this may explain the cautious labeling of it in the departmental

records as the work of the artist's school and probably explains why it has remained unpublished for so long.[20]

The Chicago drawing, which is of excellent quality, cannot be a copy of the 1644 Budapest painting. Not only are the figures radically different in scale—in the drawing they are much smaller in relation to the overall picture space than their painted counterparts—but they are also quite different in pose. The Art Institute's work appears to be Guercino's only large-scale, finished *modello* in pen and wash to have survived, though it is possible that others may turn up someday.[21] His only other large, drawn *modello*, in black chalk, is in the Royal Library, Windsor Castle, and was made more than twenty years earlier for his great altarpiece of the *Burial and Assumption into Heaven of Saint Petronilla*, painted for St. Peter's, Rome, and now in the Pinacoteca Capitolina.[22]

Guercino's *Flagellation* altarpiece was commissioned by a certain Signor Berengani of Vicenza. Living at a distance

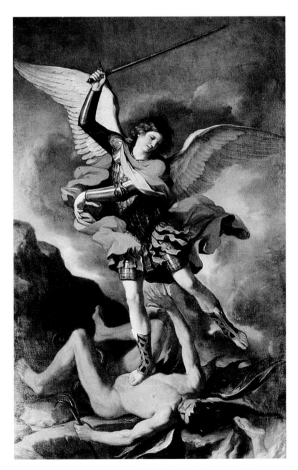

FIGURE 14. Guercino. *Saint Michael the Archangel*, 1644. Oil on canvas; 308 x 198 cm (121 ¼ x 78 in.). Chiesa di San Nicola, Fabriano.

from Rome, Berengani must have quite reasonably insisted on seeing a *modello* before finalizing his contract with the artist and, unusually, Guercino must have obliged, saving time and materials by dispatching a finished drawing instead of an oil *bozzetto*, a color sketch on a more reduced scale than the planned, final work. His usual, very rigid practice was to provide his clients with neither: after all, they were paying for a picture that would arrive in due course, and he refused to waste his time by providing preliminary extras for free.

Returning to the Art Institute's *modello*, we may at first suspect that the torturer in close-fitting pants, who cuffs at Christ with his fists, was dropped from the finished altarpiece because his trousers were too tight: he might have proved a distraction to susceptible worshippers. But the decision to omit so important a participant would have saved the Berengani family some 100 *scudi*, Guercino's standard charge for a full-length figure, which seems a more practical reason for his disappearance. Although this is second-guessing Guercino, another reason why the boxing torturer may have had to go was that the artist decided to enlarge all the figures in the composition in relation to the overall picture space. As a result, there was simply no longer room for three such ruffians. The boxing torturer, who also wields a bundle of sticks, the handle of which can be just seen near the right edge of the drawing, was therefore merged with the hollow-cheeked man behind him. The artist retained the rather more elegantly conceived figure wielding a cat-o'-nine-tails, with some modifications, at left (see fig. 17): his coy pinching of Christ's shoulder before delivering his blows was substituted in the painting by a glimpse of Pilate's pointing hand. The erased lines of a spectator behind this tormentor may also be seen in this detail, largely masked out by the dark shadow of the wall.

We get a further glimpse of how Guercino orchestrated *The Flagellation of Christ* by comparing the Chicago drawing with the other, less-finished preparatory sketches that must have post-dated it.[23] In the Ashmolean Museum, Oxford, a red chalk drawing of the figure of Christ with an executioner standing behind him (fig. 18) shows the same torturer with hollow cheeks, deep-set eyes, and a long, insubstantial moustache as appears in the Chicago drawing. In the latter, he is depicted wielding a bundle of twigs, his body mostly concealed by his boxing companion.[24]

Pilate and his henchmen, who occupy the upper balcony in the Art Institute's drawing, had to be brought to the wings of the stage itself as the composition of *The*

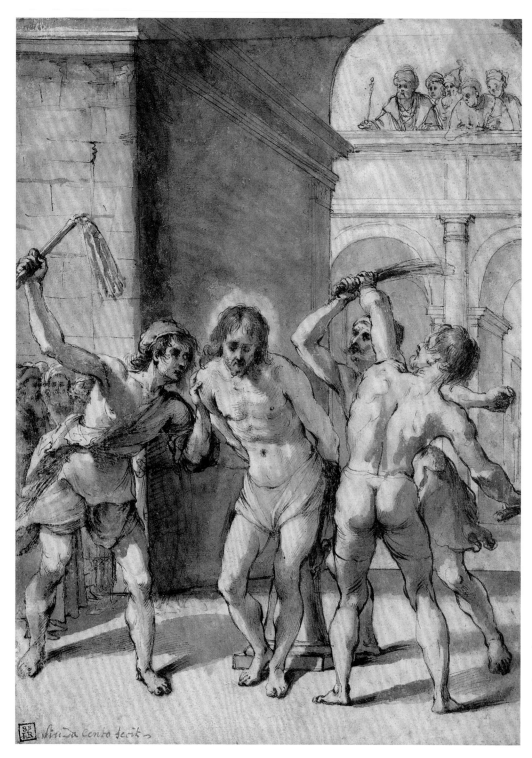

FIGURE 15. Guercino. *Modello for "The Flagellation of Christ,"* 1644. Pen and brown ink, with brush and brown wash, over incising and touches of graphite, on cream laid paper, laid down on cream laid paper; 36.9 x 26.6 cm (14 ¹/₂ x 10 ¹/₂ in.). Charles Deering Collection, 1927.2586.

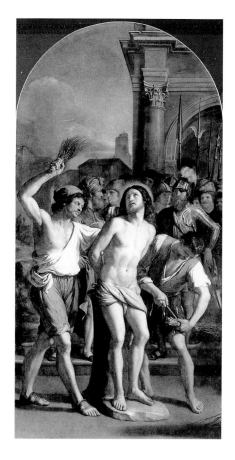

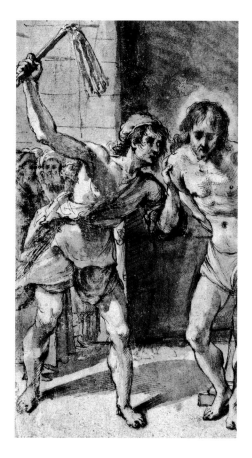

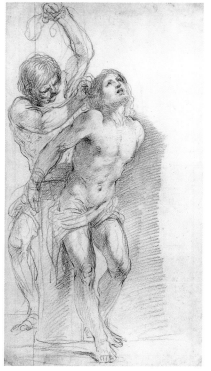

FIGURE 16 (at top left). Guercino.
The Flagellation of Christ, 1644. Oil on
canvas; 351 x 176.5 cm (138 ¼ x 69 ½ in.).
Museum of Fine Arts, Budapest.

FIGURE 17 (at top right). Detail of *Modello
for "The Flagellation of Christ"* (fig. 15),
showing the tormentor at left.

FIGURE 18 (at bottom left). Guercino.
Study for "The Flagellation of Christ,"
1644. Red chalk, with a ruled incised line;
36 x 20.3 cm (14 ⅛ x 8 in.). Ashmolean
Museum, Oxford, KTP 863.

FIGURE 19 (at bottom right). Guercino.
Study for "The Flagellation of Christ,"
1644. Red chalk; 40 x 26.6 cm (15 ¾ x 10
½ in.). Galleria del Palazzo Rosso, Genoa,
D 1698.

FIGURE 20. Pietro da Cortona (Italian, 1596–1669). *An Artist's Studio during an Earthquake*, c. 1660. Pen and brown ink, with brush and gray wash, over charcoal, on cream laid paper; 21.1 x 27.1 cm (8 5/16 x 10 11/16 in.). Gift of Charles R. Feldstein, 1991.405.

Flagellation developed. In a particularly fine, red chalk study for the whole composition in the Palazzo Rosso, Genoa (fig. 19), Guercino therefore squeezed Pilate and his associates in on the right-hand side, with the main turbaned figure (perhaps Pilate himself) counting out money into Judas's outstretched hand.[25] In the finished painting, Pilate and his retinue, including a soldier in armor, appear in the background, center, and right, more shifty looking and awkward than ever.

The final work in my sequence of "new discoveries," this time found in the Art Institute's cache of anonymous Italian drawings, represents an artist's studio during an earthquake (fig. 20) and can now be firmly attributed to the Italian High Baroque painter par excellence, Pietro da Cortona.[26] Of all those considered thus far, it is the only drawing not donated to the museum by Gurley or Deering—rather, it was presented in 1991 by Charles R. Feldstein. In its style and spontaneous execution, it is characteristic of Cortona's late drawings of the 1650s and the 1660s, such as the Art Institute's own early idea (fig. 21) for *The Martyrdom of Saint Stephen*, which the artist painted for the Church of San Ambrogio della Massima toward the end of his second Roman period (1647 to 1669).[27] The sketchy handling of the architectural elements finds parallels in other drawings from Cortona's maturity, including the compositional study for *The Age of Bronze* (1640/41; Graphische Sammlung, Munich), especially its upper-right quadrant before it was revised by a paper

correction (now hinged only at the top corner, so that both solutions are visible).[28]

Although the attribution has been resolved, the drawing itself leaves many questions unanswered. The scene is clearly an artist's studio at the moment of a severe tremor or earthquake: the painter's canvas and easel topple forward, and statues and mannequins tumble from their pedestals at center right. Behind the easel a figure clings desperately to a ladder, presumably having been at work only moments earlier on the decoration of the ceiling. There are not known to have been any major earthquakes in Rome during Cortona's lifetime, although Mount Etna, on the east coast of Sicily, erupted from March to July 1669. With its unusual subject and mysterious function, this last drawing is an appropriate illustration of just how much research remains to be undertaken, not only in the collection of Italian Baroque drawings at the Art Institute of Chicago, but in the whole topic of Italian Baroque drawings in general.

FIGURE 21. Pietro da Cortona. *The Martyrdom of Saint Stephen*, c. 1660. Pen and brown ink, on cream laid paper; laid down; 31 x 19 cm (12 3/16 x 7 1/2 in.). Leonora Hall Gurley Memorial Collection, 1922.495.

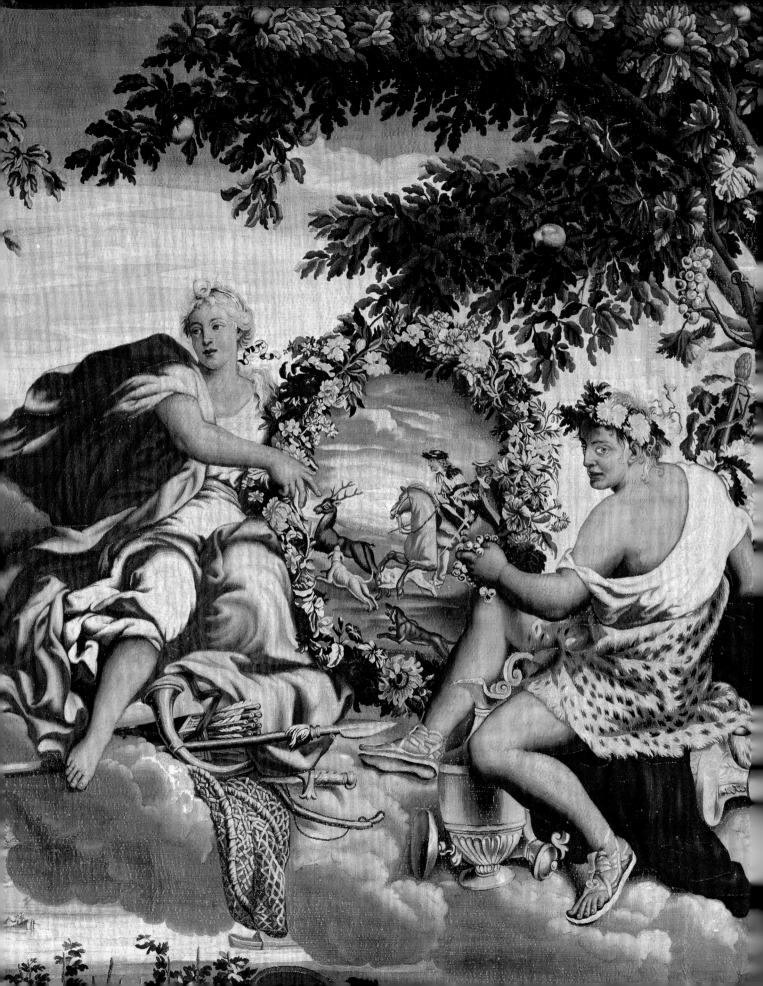

Autumn *and* Winter:
Two Gobelins Tapestries after Charles Le Brun

CHRISTA C. MAYER THURMAN

Christa C. Mayer Thurman Curator of Textiles

KOENRAAD BROSENS

Postdoctoral Fellow of the Fund for Scientific Research-Flanders (Belgium)
Visiting Professor, Katholieke Universiteit Leuven

*A*utumn and *Winter* (figs. 1–2) are examples of the Art Institute of Chicago's virtually unknown tapestry collection, which comprises more than eighty European works.[1] While the earliest of these objects were acquired in 1890, it was in 1995 that an ambitious conservation campaign was started to preserve these important holdings. Most of the tapestries were sent to the Royal Manufacturers of Tapestry De Wit in Mechelen, Belgium, a laboratory that possesses a technical expertise unique in the world.[2] This conservation effort, which is now coming to a close, is the first phase of an unparalleled project: returned to their original splendor, the museum's tapestries will be featured in a major publication entitled *European Tapestries in the Art Institute of Chicago* and showcased in an accompanying exhibition scheduled for 2008. The following essay is a forerunner of this upcoming publication and exhibition.

The provenance of *Autumn* and *Winter* can be traced back to the early nineteenth century. In 1838 a visitor to Marple Hall in Cheshire, England, included a brief description of the two tapestries in his journal; in 1880, still hanging in the drawing room of Marple Hall, they were described as "two fine pieces of old French tapestry, representing Diana and her Nymphs and Time and Pleasure, and having a crown and the letters *LL* interwoven into it."[3] In 1929 the Marple Hall collection was sold at auction. Art dealer Henry Symons, who was active in New York and London, presumably bought the tapestries and immediately sold them to the renowned Manhattan firm P. W. French and Company.[4] It was from French and Company that the media mogul and collector William Randolph Hearst acquired the pieces in 1930. The Hearst Foundation offered both tapestries as an unrestricted gift to the Art Institute in Hearst's memory in 1954, two years after his death.

OPPOSITE: Detail of *Autumn* (fig. 1).

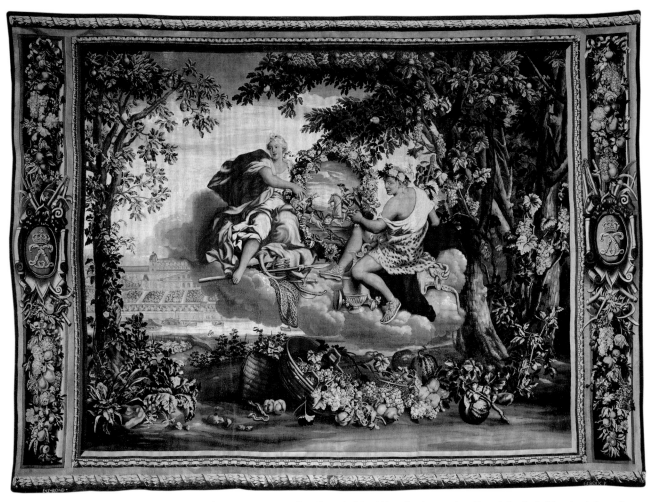

FIGURE 1. After a cartoon by Charles Le Brun (French, 1619–1690). Woven by Etienne Le Blond (French, 1652–1727) and Jean de La Croix (French, 1628–1712). *Autumn*, 1700/20. Wool and silk, slit and double interlocking tapestry weave; 380.8 x 530.3 cm (150 x 208 ³/₄ in.). Gift of the Hearst Foundation in memory of William Randolph Hearst, 1954.260. Shown after full conservation at the Royal Manufacturers of Tapestry De Wit, Mechelen, Belgium.

Autumn has already undergone painstaking conservation in Belgium, underwritten by Janice (Mrs. John K., Jr.) Notz, a member of both the Textile Committee and the Textile Society of the Art Institute of Chicago. *Winter* was in equally precarious condition and is currently being conserved at the De Wit laboratory; much of its original magnificence is slowly but surely being recovered through efforts financed by the Textile Society.

Autumn presents Diana and Bacchus floating on a cloud. The Roman goddess of the hunt, Diana is identifiable by the bow, arrow, spear, and horn at her feet and is an appropriate addition to this depiction of the hunting season. The goddess holds a floral wreath featuring a stag hunt, further underscoring the link between fall and the hunt (see detail, p. 60). Her

companion, Bacchus, is the god of wine, which explains his presence in this representation of autumn, the time of the grape harvest. Grapes and other fruits and vegetables associated with fall can be seen in the foreground. The seventeenth-century French administrator and art historian André Félibien, who was historiographer of the Bâtiments du Roi (Residences of the King), identified the castle visible in the background as the Château de Saint-Germain-en-Laye, a royal retreat just outside Paris (see fig. 11).[5]

Winter, by contrast, reveals a barren landscape, above which a winged Saturn and Juventas repose on a large cloud. The god of agriculture and time, Saturn is depicted with an hourglass. While his cult was never very popular, Saturnalia, one of the major festivals of the Roman year,

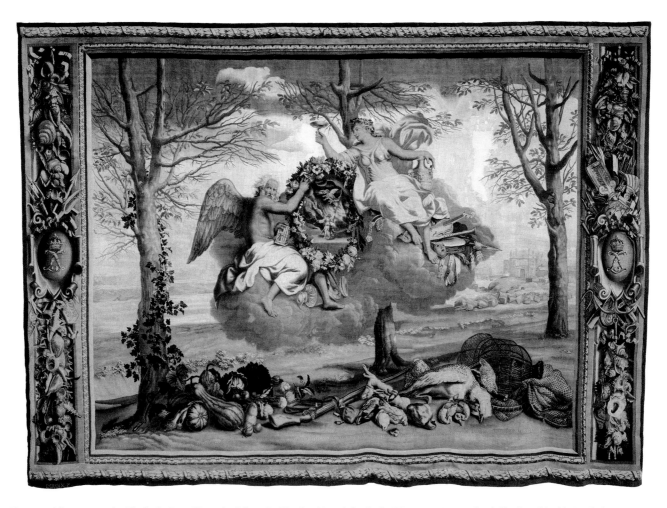

FIGURE 2. After a cartoon by Charles Le Brun. Woven by Etienne Le Blond and Jean de La Croix. *Winter*, 1700/20. Wool and silk, slit and double interlocking tapestry weave, bottom selvage present; 541.3 x 383.3 cm (150 x 208 ¾ in.). Gift of the Hearst Foundation in memory of William Randolph Hearst, 1954.261. Shown before conservation.

was dedicated to him. Originally held only on December 17, the holiday was later extended into a week-long event in which business was suspended, the roles of masters and slaves reversed, moral restrictions loosened, and gifts exchanged. The Saturnalia obviously explains Saturn's inclusion in this scene and also provides a reason for the appearance of Juventas, who, as her cup suggests, was responsible for pouring the nectar of the gods on Mount Olympus and attending all festivities and banquets. The musical instruments and the mask at her feet allude to ballet performances and masked balls, which were favorite pastimes of French kings and their courtiers. Saturn holds a floral wreath that also refers to leisure and entertainment, as it features a ballet scene in its center. In the foreground

a variety of winter vegetables, such as gourds, can be seen along with a cage, nets, a gun, and the results of a finished, successful hunt, which links *Winter* to *Autumn*. Félibien identified the buildings on the right of the tapestry as those belonging to the Palais du Louvre in Paris.[6]

Both tapestries carry identical borders showing interlocking *L*s, the cipher of the French King Louis XIV (r. 1643–1715); these are supplemented by additional devices of armor above and below, juxtaposed and intertwined with floral garlands at both ends. *Winter* is signed E.LE. BLOND, while *Autumn* bears the signatures E.LE.BLOND. and L.CROIX.P. The former signature stands for Etienne Le Blond, who died in 1727 at the age of seventy-five.[7] The latter can be read as [DE] L[A] CROIX P[ÈRE] (De La Croix

the Elder) and refers to Jean de La Croix, who died in 1712 at the age of eighty-four.[8]

Both Le Blond and La Croix were employed as tapestry weavers at the Manufacture royale des meubles de la couronne (Royal Manufactory of Furniture for the Crown), which was established in 1662 by Jean-Baptiste Colbert, minister of finance under Louis XIV, who developed a policy of state entrepreneurship now known as Colbertism.[9] An absolute monarch after the death of his minister Mazarin in 1661, the king identified himself with Apollo, the god of the sun, and thus came to be called the Sun King. Although he was not a connoisseur, he realized that art was an important means of representing his glory and greatness as well as that of his nation, with which he identified himself intimately in his famous comment "L'état, c'est moi" (I am the State). The Manufacture royale, which was charged with creating the king's image, was located in the Paris suburb of Saint-Marcel on the premises of a former dye works run by the Gobelins family; soon the enterprise became known as the Royal Gobelins Manufactory or by its abbreviated form, the Gobelins.[10] There Colbert assembled an army of artists and skilled craftsmen who produced luxurious furniture, gold and silver work, locks, marquetry, mosaics, and tapestries.

There were several tapestry workshops at the Gobelins, directed by entrepreneurs who supervised more than 250 weavers.[11] Although they were employed by the king, these businessmen were allowed to take on private commissions that they carried out either in the manufactory itself or in shops that they owned outside its confines.[12] While extensive records pertaining to royal commissions have survived, there are unfortunately no known documents that shed light on the private endeavors, which explains why very little attention has been paid to this aspect of tapestry production at the company.

Both *basse lisse* (low-warp) and *haute lisse* (high-warp) looms were used at the Manufacture royale (see fig. 3). The weaving technique, and the resulting weave structure, are identical on both types of loom.[13] Low-warp looms permitted weavers to work faster because they were able to manipulate the threads by means of treadles, thus freeing both hands to continue the weaving. In contrast, on the high-warp loom, one hand was frequently required to

Tapisserie de Basse Lisse des Gobelins, Attelier et différentes Opérations des ouvriers employés à la Basse Lisse.

FIGURE 3. *Interior View of a Gobelins Basse-Lisse Workshop*, published in Denis Diderot's *Encyclopédie*, 1765.

manipulate the warps, thus slowing the weaving process. Low-warp weavers, working from the back of the loom on what would become the reverse of the completed tapestry, positioned a cartoon—a full-scale rendering of the tapestry's composition, painted in oil on canvas—below the horizontal threads, producing the tapestry as its mirror image. In contrast, high-warp weavers, who also worked from the back of the loom, hung the cartoon on the wall behind them, consulting its image as it was reflected in a mirror placed on the opposite side of the warp threads that were facing them. They thus created a tapestry in the same orientation as the cartoon.

Prior to 1600, tapestry production in Paris had been sustained by high-warp workshops. At the turn of the century, however, Louis XIV's grandfather, Henri IV, lured Flemish tapestry weavers and entrepreneurs to the French capital, creating a low-warp production unit.[14] Their descendants and later Flemish immigrants manned low-warp looms throughout the seventeenth century, and they formed an important subgroup among the Gobelins weavers. It is known that Le Blond and La Croix, who was of Flemish origin, directed low-warp workshops.[15]

Before its temporary closure in 1694, the creative genius behind the Gobelins was Charles Le Brun (see fig. 4).[16] Le Brun, who studied in Rome between 1642 and 1646, was one of twelve founders of the Royal Academy of Painting in 1648. Ten years later he entered the service of Nicolas Fouquet, superintendent of finances and chancellor of the exchequer, who was building an awe-inspiring palace at Vaux-le-Vicomte.[17] Between 1658 and 1661, Le Brun commanded an army of cabinetmakers, gilders, painters, sculptors, and tapestry weavers. He created his first tapestry sets during that period, including the famous *Portières des Renommées* and *The History of Meleager and Atalanta*.[18] In 1661, when his palace was completed, Fouquet arranged festivities in honor of Louis XIV. The monarch, however, was outraged by his subordinate's kinglike demeanor—and astounded by Le Brun's genius. Fouquet was arrested, and Le Brun was engaged as First Painter to the King, a title he officially received in 1664.

In 1663 Le Brun became director of the newly established Gobelins manufactory, providing its entrepreneurs with fresh designs.[19] He had an apartment on the premises so that he "could see their [the employees'] work whenever he liked; could correct them; could see that they made progress and did not waste their time."[20] The professional contact between Le Brun and the Gobelins entrepreneurs also

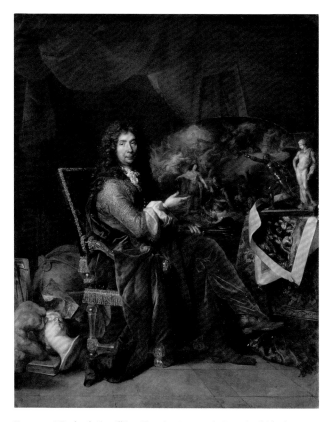

FIGURE 4. Nicolas de Largillière (French, 1656–1746). *Portrait of Charles Le Brun*. Oil on canvas; 232 x 187 cm (91 3/8 x 73 5/8 in.). Musée du Louvre, Paris.

reached a rather personal level: Le Brun was, for example, present as a witness at the wedding of La Croix's daughter Polixène in 1677.[21] The ambiance at the Manufacture royale and the omnipresence of Le Brun are tellingly summarized in the *Mercure galant*, a newspaper of the time:

> While legions of workers executed his designs, there were also countless others who did nothing but weave tapestries according to his plans. He confected those of the *Battle and Triumph of Constantine*, those of the *History of the King* and of *Alexander*, those of royal houses and of the *Seasons*, the *Elements* and a host of others. We can conclude that every day he put thousands of hands to work and that his genius was universal.[22]

Le Brun, however, complained in private; according to one of his friends, the First Painter had made clear that "he was not happy at the Gobelins, because the more he did, the more they wanted him to do, without ever telling him that they were pleased with his work."[23]

FIGURE 5. Sébastien Le Clerc (French, 1637–1714) after Charles Le Brun. *Spring*, 1670. Engraving; 38.5 x 47.4 cm (15 ⅛ x 18 ⅛ in.). Musée du Louvre, Paris.

FIGURE 6. Sébastien Le Clerc after Charles Le Brun. *Summer*, 1670. Engraving; 38.7 x 48.1 cm (15 ¼ x 19 in.). Musée du Louvre, Paris.

Autumn and *Winter* were woven according to Le Brun's designs of *The Seasons* that are mentioned in the *Mercure galant*. The series comprised eight works in all.[24] The four main scenes, all presenting two deities floating on a cloud, a royal residence, and attributes associated with one of the seasons, were published as engravings in 1670 (figs. 5–8). *Spring* (fig. 5) depicts Mars and Venus in front of the Château de Versailles. The goddess of love and beauty, Venus was originally a nature deity and patroness of gardens, which explains why she is included here. Mars is known as the god of war— wars were mostly started or renewed in spring— but he was also associated with spring and fertility, justifying his presence in this scene. *Summer* (fig. 6) illustrates Apollo and Minerva before the Château de Fontainebleau. Apollo was the god of music and light; he was also sometimes identified with Helios, the sun god, which explains his connection to this time of the year. Minerva, meanwhile, was the goddess of wisdom, medicine, and the arts and sciences, all of which reached their apex during the reign of the Sun King. The floral wreath they are holding shows the Louvre. In addition to the four main compositions, *The Seasons* included four *entre-fenêtres* scenes—narrower, smaller, upright panels that could be placed in between windows. These show winged boys working in a garden where the flowers, fruits, and plants allude to each of the four seasons.[25] While Le Brun designed all eight works in the suite, Adam-Frans van der Meulen, a painter who was born and trained in Brussels but moved to Paris in 1664, orchestrated the small scenes that appear in the wreaths held by the gods in *Spring* and *Autumn* (see detail, p. 60).[26] Afterward, a handful of painters transformed these plans into two suites of cartoons that enabled sets to be woven simultaneously in the high-warp and the low-warp workshops.[27] Archival documents reveal that the original cartoons of *Summer* and *Autumn* used by the low-warp weavers were replaced by copies around 1713 or 1714.[28] This is unsurprising, since cartoons were routinely damaged during the weaving process and frequently needed to be restored or replaced. One observer, writing at the end of the seventeenth century, stated: "It must be noted that the first two or three suites that are

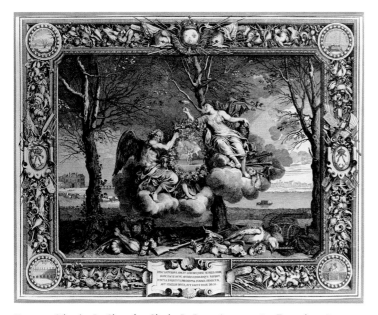

FIGURE 7. Sébastien Le Clerc after Charles Le Brun. *Autumn*, 1670. Engraving; 38 x 47 cm (15 x 18 ½ in.). Musée national des Châteaux de Versailles et de Trianon, Versailles.

FIGURE 8. Sébastien Le Clerc after Charles Le Brun. *Winter*, 1670. Engraving; 38 x 47 cm (15 x 18 ½ in.). Musée national des Châteaux de Versailles et de Trianon, Versailles.

woven after new cartoons are much better than the later suites, since a lot of damage happens to the cartoons while weaving the tapestries."[29] When in 1794 an inventory of the Gobelins cartoons was recorded, only a small number were listed; most of them were damaged, and only a few fragments have survived.[30]

The Seasons appears to have been woven repeatedly at the Gobelins, almost exclusively in the low-warp workshops. Of the seven suites produced between 1669 and 1716 for the Garde-meuble de la couronne, the royal furniture collection, only one was woven on high-warp looms.[31] Jean de La Croix produced four low-warp editions between 1669 and about 1682; these were woven with gold threads and have different borders than the tapestries at the Art Institute. The fifth low-warp set was created by Etienne Le Blond between 1709 and 1711; it remained in storage on the Gobelins premises until 1737, when it was delivered to the Garde-meuble; all four pieces are still in the French national collection (see fig. 9).[32] We know that the last low-warp suite was woven by Jean Souet, Jean de La Fraye, Jean de La Croix and his son Dominique between 1712 and January 1714. This edition remained at the Gobelins until 1748, when the tapestries were shipped to Rome to decorate the French Embassy; in 1757 they were moved to Vienna. Although the present location of these works is unknown, it has been assumed that the Art Institute's *Autumn* and *Winter* were originally part of this suite.[33] The E.LE.BLOND. signatures on the Chicago pieces, however, demonstrate that they did not belong to this set. Consequently they were never part of the Garde-meuble's collection, which implies that they were produced as part of a private commission.[34] Given the death dates of Jean de La Croix and Etienne Le Blond, it seems certain that *Autumn* was woven—or at least started—prior to 1712 and *Winter* in 1727 at the latest.

Even though the Chicago *Autumn* and *Winter* were not in the French royal collection, we can safely assume that they were commissioned by a fervent supporter of the Sun King, for the borders and the iconographic program of the pieces celebrate his reign. Indeed, Le Brun's *Seasons* as a whole was part of the propaganda machine that

helped create the public image of the French king. Prior to its closure in 1694, the Gobelins played an important role in what one recent scholar has termed the "fabrication of Louis XIV," since most of the luxury items produced there were used to embellish the numerous royal castles and palaces in France and ambassadorial residences abroad.[35] To a great extent, such splendor was designed to impress foreign monarchs and politicians, who could not have helped but gaze in wonder at the wealth and power of Louis XIV and his kingdom. As a special treat, statesmen visiting Paris were often guided through the spectacular workshops of the Manufacture royale. According to one seventeenth-century historiographer, "the princes and ambassadors of all of Europe do not leave France without having visited [the Gobelins]."[36] It was Charles Le Brun who received "the foreign ministers during their stay in Paris and he often dined with them"; "everybody, no matter how far he traveled to come to the court of Louis the Great, took great delight in seeing Le Brun and in talking with him."[37] To make sure that his visitors never forgot France's plenty—and to butter them up—Louis XIV often presented Gobelins tapestries as gifts. In 1682, for instance, he sent one of La Croix's *Seasons* suites as a gift to a Danish minister.[38]

The nature and raison d'être of the manufactory explains why the imagery and subject matter developed at the Gobelins was focused completely on the Sun King. In 1663 Colbert had installed a scholarly committee, the Petite académie, which was charged with conceiving iconographic programs for new tapestry sets. According to the poet and storyteller Charles Perrault, one of its members, "M. Colbert asked us to provide concepts for tapestry sets that would be woven at the Gobelins. We presented him with several. They chose the four elements because it was possible to include references to the glory of the king. . . . We then conceived the four seasons, after the model of the four elements."[39]

André Félibien's 1670 booklet *Tapisseries du Roy: ou sont representez les quatre elemens et les quatre saisons de l'année* (*The King's Tapestries: In Which are Represented the Four Elements and the Four Seasons of the Year*) reveals how the imagery of *The Seasons* could be translated into a panegyric on the virtues of Louis XIV. According to Félibien, the Sun King "made the seasons more beautiful and fertile."[40] *Autumn* was an "allegory full of truth,"

FIGURE 9. Twentieth-century interior view of the Empress's Antechamber in the Grand Apartments of the Château de Fontainebleau, showing *Winter* and *Summer*.

because "so many virtues that shine in him [His Majesty] are the same virtues for which shrines were erected in antiquity."[41] Explaining *Winter* was more challenging, as it alludes to relaxation and leisure, yet Félibien achieved his ambition to flatter the king by focusing on Saturn's hourglass, explaining, "Even if the King participates in these pastimes, he does not waste hours that he reserves for his more important tasks."[42] Surprisingly, Félibien paid little attention to the castles and palaces depicted in *The Seasons*, simply stating that "one has painted a royal residence in each of the scenes, chosen among the other residences because it is the most pleasurable place to stay during the season in which it is featured."[43]

It can be argued, however, that either the Petite académie or Le Brun himself chose these buildings because they held special meaning for Louis XIV and the French monarchy. This is corroborated by a closer examination of the buildings depicted in *Winter*. Félibien identified them as the Louvre, remarking, "one sees the Grande Galerie and the great pavilions that decorate this superb palace."[44] A contemporary print issued by the Pérelle workshop, however, shows that it is not the Louvre but rather the Porte de la Conférence—since the tapestry was woven on a low-warp loom, the buildings are depicted in mirror image (see figs. 2, 10).[45] The lost Porte de la Conférence, located on what is now the place de la Concorde, was not a royal

residence, so why did the committee or the First Painter decide to include this particular building in the series?

The Porte de la Conférence was erected in 1633 by Louis XIV's father, Louis XIII, its name commemorating the conference of Suresnes, near Paris, in 1593.[46] That meeting ended a French civil war and led to the conversion of the Protestant Henri IV, Louis XIV's grandfather, who became recognized as the legitimate king of France—the first of the Bourbon kings who would rule the country until the end of the eighteenth century. In 1649, when Paris was torn apart by the Fronde, a civil war between supporters of absolutist rule on the one hand and "revolutionaries" on the other, the eleven-year-old Louis and his mother, Anne of Austria, fled the Louvre through the Porte de la Conférence, and it can be assumed that they re-entered Paris the same way after the Fronde was decided in favor of the first faction.[47] The Porte de la Conférence thus symbolized the victory of Bourbon absolutist rule over "democratic" unrest. In *Winter*,

the pavilion that is partly hidden behind the Porte de la Conférence is not a part of the Louvre but instead a section of the now lost Château de Tuileries, Louis XIV's prime residence in Paris before he moved to Versailles in 1682.[48]

In his account of *Autumn*, Félibien was presumably right when he identified the Château de Saint-Germain-en-Laye, which is depicted with a high degree of accuracy (see figs. 1, 11), as an enjoyable place to dwell during the fall. Like the Porte de la Conférence, however, it was also of great symbolic significance to Louis XIV. Throughout the sixteenth and seventeenth centuries, the château had been one of the prime residences of the French kings. Louis XIV was born there, took shelter there during the Fronde, and used the castle as one of his favorite residences outside the capital between 1661 and 1681.[49] Therefore, it can be seen to have functioned both as a stronghold and symbol of the king's absolute power. The edifices depicted in *Spring* (the Orangerie at Versailles) and *Summer* (Fontainebleau and the

FIGURE 10. Pérelle Family (French, active c. 1635–95). *View of the Porte de la Conférence,* 1661/1715. Engraving on paper; 20 x 29 cm (7 7/8 x 11 7/16 in.). Musée national des Châteaux de Versailles et de Trianon, Versailles.

FIGURE 11. Adam Pérelle (French, 1638–1695). *View of the Château de Saint-Germain-en-Laye*, 17th century. Pen and ink, on paper; 153 x 263 cm (60 ¼ x 103 ½ in.). Musée Condé, Chantilly.

Louvre) also alluded to the rich past, magnificent present, and bright future of Bourbon France, linking old absolutist icons with new ones that were still under construction.

As we have seen, Charles Perrault's account of the activities of the Petite académie reveals that the iconographic program of *The Seasons* paralleled that of a closely related set, *The Elements*, the first suite of which was woven between 1666 and 1669.[50] In *Tapisseries du Roy*, Félibien explained the allegorical meaning of the series; basically, it praised Louis XIV because he had "changed all the elements, which were in a frightening state of confusion."[51] *The Elements* was also related formally to *The Seasons*, as each individual tapestry presents two deities floating on a cloud along with attributes and animals that relate to the element in question.

While *The Elements* and *The Seasons* conveyed a message in an allegorical disguise, other tapestry sets that Le Brun designed for the Gobelins were more straightforward. Between 1664 and 1686, the king commissioned no less than eight suites of Le Brun's *Story of Alexander*.[52] The Sun King's interest in an emperor who had conquered the world by age thirty is hardly surprising, and, by choosing Alexander as

his visual equivalent, he was able to broadcast his ambition throughout Europe. With *The Story of the King* woven from 1665 onward, Le Brun lifted the allegorical veil completely, presenting fourteen documentary views taken from Louis XIV's reign, including a visit to the Gobelins manufactory (fig. 12).[53] Another series, *The Months/The Royal Residences*, produced from 1668 onward, also offers documentary evidence instead of symbolism, demonstrating the monarch's glory through a survey of his most magnificent palaces and castles, including the Château de Saint-Germain.[54]

When the Gobelins reopened in 1699, the royal administration and the entrepreneurs running its tapestry workshops fully realized that in order to sustain production, the enterprise had to market more tapestry sets that appealed to private customers rather than to the propagandistic impulses of the monarchy. Famous early-eighteenth-century Gobelins tapestry sets such as the *Portières des Dieux*, which depicted Olympian deities in arabesque settings, and *The Story of Don Quixote* differed completely from Le Brun's allegorical series glorifying the French king.[55] The Art Institute's *Autumn* and *Winter* were

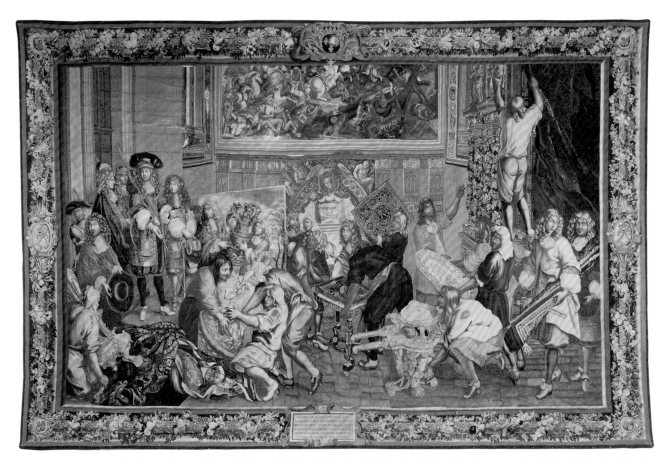

FIGURE 12. After a cartoon by Charles Le Brun. Woven by Etienne Le Blond. *Visit of Louis XIV to the Gobelins Manufactory*, 1729/34. Wool and silk, slit and double interlocking tapestry weave; 375 x 580 cm (147 ⅛ x 228 ⅜ in.). Musée national des Châteaux de Versailles et de Trianon, Versailles.

thus produced at right about the time that the *gôut moderne* (modern taste)—now known as the Regency or Rococo style—came to dominate the fashionable artistic scene, and they can therefore be regarded as one of the latest creations of the monumental style of Louis XIV, which existed to evoke the grandeur of the Sun King's France.

"A Finesse of the Crayon":
Eighteenth-Century French Portraits in Pastel

SUZANNE FOLDS MCCULLAGH

Anne Vogt Fuller and Marion Titus Searle Curator of Earlier Prints and Drawings

The Art Institute of Chicago has become known in recent years as one of the finest repositories in North America of eighteenth-century pastel portraiture. This would have come as a surprise to many over fifty years ago, when the first such acquisition was made; but the seeds of interest were planted, and curator Harold Joachim subsequently found support for this formerly neglected area with the help of philanthropist Helen Regenstein.[1] Together, they were responsible for a significant number of purchases, including the pastel by François Boucher and the portraits of Cardinal de La Rochefoucault, Maurice-Quentin de La Tour, Louis de Silvestre, and Madame Chardin featured in this essay (see figs. 6, 1, 5, 12, and 15). But the real project of assembling a representative collection of pastel art began after Joachim's death in 1984 and became a collaborative effort among the museum's curators of prints and drawings, then director James N. Wood, and Helen Regenstein's children, Betsy Hartman and Joseph Regenstein, Jr. Over the subsequent twenty years, the Art Institute has been able to assemble, with the help of other generous donors and major acquisition funds, a collection that is distinguished by important works of major artists, offering an unusually rich picture of the rise of the pastel in eighteenth-century France.

While the pastel was not pioneered in France, color in drawn portraits seems to have played an essential role in French art from the seventeenth century onward, with the development of fabricated colored chalks. This can be seen in the court portraits by Daniel Dumonstier and his circle, including the Art Institute's impressive likeness of Cardinal de La Rochefoucault (fig. 1), in which the artist used red chalk to enhance what is essentially a black chalk portrait, giving a pulsating sense of flesh and blood to the figure's ear, despite its dry modeling. This severe work, drawn with minimal means and later engraved, adheres to a French portrait tradition

OPPOSITE: Detail of *Portrait of Philippe Coypel and His Wife* (fig. 7).

FIGURE 1. Daniel Dumonstier (French, 1574–1646). *Bust of Cardinal de La Rochefoucault*, 1624. Black and red chalk, with stumping, and brush and pale yellow and orange wash, on ivory laid paper, laid down on cream laid paper; 43.7 x 33.8 cm (17 ¹/₄ x 13 ¹/₄ in.). Gift of the Joseph and Helen Regenstein Foundation, 1959.35.

In the Art Institute, the bridge from these early artists to those of the eighteenth century is provided by no less than Antoine Watteau, whose *Old Savoyard* (fig. 3) demonstrates his admiration for the draftsmanship of Peter Paul Rubens in its blending of red and black chalks. This drawing responds indirectly to the academic debates of the day, which concerned the relative merits of line versus color and pitted the Poussinistes, who favored the classicism and dry linearity of Nicolas Poussin, against the Rubenistes, who maintained the superiority of color and painterly handling as employed by Rubens. The virtue of colored chalk—and pastel in particular—was that it satisfied both camps by supplying both color and line simultaneously. Over the brief decade or so of his career, Watteau evolved from an artist who worked exclusively in fine red chalk, introducing black chalk accents and—by the time he drew this work, in about 1715—fully integrating chalks and stumping to achieve a heightened color and painterly quality that is especially notable in the large box on the figure's back. It is not surprising, therefore, that this unorthodox artist would have become a good friend, host (with his patron, the financier and collector Pierre Crozat), and champion of Rosalba Carriera, the Venetian artist who is credited with bringing the art of pastel to France during her Parisian visit of 1720 and 1721.

of employing the finest point of chalks on white paper, as established by François Clouet in the sixteenth century.[2] A similar forthrightness characterizes even the humbler character studies attributed to the itinerant artist known as Lagneau, including a portrait of an old man (fig. 2), rendered with a much broader use of red and black chalks on coarser paper. Here, the chalks are stumped, or smudged, producing a *sfumato* background atmosphere that offers a strong contrast with Dumonstier's technique.

A few words should be said here about the nature of pastel and its role as a medium that serves as a cross between painting and drawing. Throughout its history, pastel generally has been considered a form of painting—particularly when used for portraiture—but in museum circles today pastels are cared for in the domain of works on paper, their most frequent support. Pastel crayons are

fabricated from color pigments, mineral fillers (which add physical substance), and a binding medium such as gum arabic. The pigments, fillers, and binder are diluted with water and ground into a fine paste, pressed, and pounded into a cylinder. Pastels are basically made of a dry pigment, and dragging them across a paper surface causes dry particles to adhere to it. However, a pastel can also be immersed in water or a solution, causing the particles to cake as they adhere to the paper; if thickly applied, they can also be worked with a brush or other implement. Highly portable and fairly colorfast, pastel allows artists to work quickly and modify their drawings easily. Pastel can be both intimate and spontaneous, as it is free of the encumbrances—the grounds and preparations, strong chemical odors, and vulnerable surfaces—of oil paintings. Over the course of time, different artists took advantage of diverse aspects of the medium. Rosalba, for example, combined a wet and dry technique, pioneering the use of stumping and dragging the flat side of the pastel over other colors for evanescent effects.

It must be said, however, that her pastel busts cannot always be considered true portraiture. She appears, on the one hand, to have favored generic, allegorical feminine figures—there must have been a market in Venice for unspecified character studies—and, on the other hand, to have made portraits that are specific to the point of being unattractive. *Young Lady with a Parrot* (fig. 4) is a rare example in which Rosalba combined the piquant ambiguity of her character studies with the compelling specificity of her portraits, producing a captivating and seductive impression. The range of the artist's technical innovations can be seen in this work, in which the background and the sitter's hair show the softness and subtlety achieved by stumping, and the details of the flowers and jewelry sit on top of the surface in a solid paste created by her wet technique. The diaphanous, gauzy material the woman holds in her hands was achieved by a "dry-brush" dragging of white pastel over the blue garment underneath. If Rosalba took works such as this one to Paris, there is little wonder that she was an overnight success, gaining royal commissions and causing the Académie royale de peinture et de sculpture

to admit her as one of its few female members.[3]

Pastel scholar Joanna M. Kosek has noted a number of reasons for the rise of interest in pastel portraiture between the date of Rosalba's visit to Paris and the waning of the medium that accompanied the shift in aesthetic preferences brought by the French Revolution.[4] In addition to the greater availability of fine pastels on the market (as well as that of large sheets of clear glass for framing them), Kosek noted the aesthetic qualities that resonated with the new palette and sensuous forms of the Rococo:

FIGURE 2. Lagneau (French, active 1590–1610). *Portrait of an Old Man*, c. 1600. Black, red, and white chalk, with stumping, and black crayon, on cream laid paper, laid down on cream laid paper; 42.3 x 29 cm (16 5/8 x 11 3/8 in.). Margaret Day Blake Collection, 1979.648.

FIGURE 3. Antoine Watteau (French, 1684–1721). *The Old Savoyard*, 1715. Red and black chalk, with stumping, on buff laid paper, laid down on cream wove card, laid down on cream board; 35.9 x 22.1 cm (14 ⅛ x 8 ¹¹/₁₆ in.). Helen Regenstein Collection, 1964.74.

Lightness and brightness are perhaps the most striking feature of this transformation of color in art, which occurred with the advent of the Age of the Enlightenment. As light levels were intensified by installing large windows and mirrors, a corresponding principle of lightness came to be applied to clothes, furniture and painting. . . . As for texture, the preference for an opaque and matte finish, embodied in the indispensable powder-puff as well as the "cloudy touch" (soft focus), fitted the characteristics of pastel exactly.[5]

Kosek also observed that the portability of the medium suited the more cosmopolitan, "itinerant lifestyle" of artists in the wake of Rosalba, not to mention the desire for quick execution and more agreeable (less messy and smelly) sittings on the part of the subjects. Indeed, the familiarity of pastels was allied to the very fabric of the cosmetic and hair fashions of the day, since they were made from the same ingredients and sold by the same apothecaries as the various powders, pomades, and rouges necessary to present oneself in public.[6]

The emergence of pastel on the Parisian stage occurred most notably with the Salon of 1737, where the young Maurice-Quentin de La Tour introduced pastels of his friends and of himself, including a finished self-portrait (1737; Musée du Louvre, Paris) that is remarkably close to the Art Institute's striking study (fig. 5). Here La Tour announced himself as the premiere pastel portraitist of his age, or "the Prince of Pastelists," as he would later be called.[7] Unusual in their intimate, informal, honest, and confrontational poses, La Tour's self-portraits declare his uncanny ability to probe an individual's psyche, to reveal the inner soul; often, he focused just on the oval of the face as he unveiled the personality beneath. Eschewing all other methods, including oils, the artist developed an unsurpassed technical ability to render insights into his subjects' temperaments.

The influence of La Tour's 1737 entries (including a portrait of Madame Boucher) is suggested by François Boucher's rare decision to adopt the pastel medium the following year, when he created a compelling study of a mischievous youth holding a carrot or a parsnip (fig. 6). Boucher, who drew with colored chalks from his earliest days and was highly

FIGURE 4. Rosalba Carriera (Italian,
1675–1757). *Young Lady with a Parrot*,
c. 1730. Pastel on blue laid paper,
mounted to laminated paper board;
60 x 50 cm (23 5/8 x 19 5/8 in.). Helen
Regenstein Collection, 1985.43.

FIGURE 5. Maurice-Quentin de La Tour (French, 1704–1788). *Self-Portrait*, c. 1737. Pastel on greenish tan laid paper; 32.4 x 24.1 cm (12 ³/₄ x 9 ¹/₂ in.). Gift of the Joseph and Helen Regenstein Foundation, 1959.242.

sought after for his paintings of a wide range of subjects, must have found pastel an appealing way to prepare a figure for a painting while creating an independent work of art that could be framed and treasured in its own right. The fact that he was willing to divert some of his income-producing energy toward the pastel medium suggests that it was quite the rage at the moment; it remained so until 1749, when the academy decided to admit no more pastelists. The spontaneity of pastel and the subtle colorism it allowed, however, lent Boucher's figures an immediacy far beyond what he could achieve in oil paint. Unlike La Tour, who carefully built up and blended his chalks into a velvety texture, Boucher allowed striations of color to sit atop the

forms, making the work seem very fresh indeed.

Pastel's increasing popularity was further underscored by the ambitious response, just five years later, of Charles-Antoine Coypel, a prodigy who had been received at the Académie royale in 1715 at age twenty-one, named curator of the royal art collections in 1719 and professor at the academy in 1730. Part of an immensely powerful artistic dynasty, Coypel was to become, like his father and grandfather before him, First Painter to the King and director of the academy. He was himself a significant collector, an aesthetic theorist, an aspiring playwright and poet, and an amateur actor. An accomplished painter, he also experimented with pastel, combining his love of

theatricality and familial devotion to create a compelling portrait of his brother Philippe and his sister-in-law Marie-Catherine Botet (fig. 7), possibly in honor of the couple's tenth anniversary.[8] Now in the Art Institute, this is without a doubt one of Coypel's surviving masterpieces: not only is this tour de force unusually large and complex, but it seeks to reproduce a wide range of brocades, laces, and silks, making it among the most ambitious pastel portraits of the era, very much in the vein of La Tour's monumental pastel of Gabriel-Bernard de Rieux (1741; private collection), with its elaborate setting and props.[9] The startlingly realistic, trompe l'oeil treatment of the figures, who lean out of a window, made an immediate impression on critics and viewers.[10] When Coypel showed this work and its (now lost) pendant in the Salon of 1742, the *Mercure de France* commented, "These new talents for pastel, of which the public knew nothing of M. Coypel, brought him great honor and drew a large crowd of spectators," noting that it was "of a striking resemblance painted with an admirable art."[11] The Abbé Desfontaines also wrote of these pictures in the same year, extolling Coypel's "rare genius" and "happy talent" and adding that they "are admirable. . . . One sees here a finesse of the crayon whose effect is to seize all the spectators and is on the point of fooling them. Only M. de la Tour can dispute these two works."[12]

It is evident from this remark that in the five short years since the Salon of 1737, La Tour had already assumed the position of supreme pastel artist in France. While Coypel's

FIGURE 6. François Boucher (French, 1703–1770). *Boy with a Carrot or Parsnip*, 1738. Pastel on buff laid paper; 30.8 x 24.3 cm (12 1/8 x 9 9/16 in.). Helen Regenstein Collection, 1971.22.

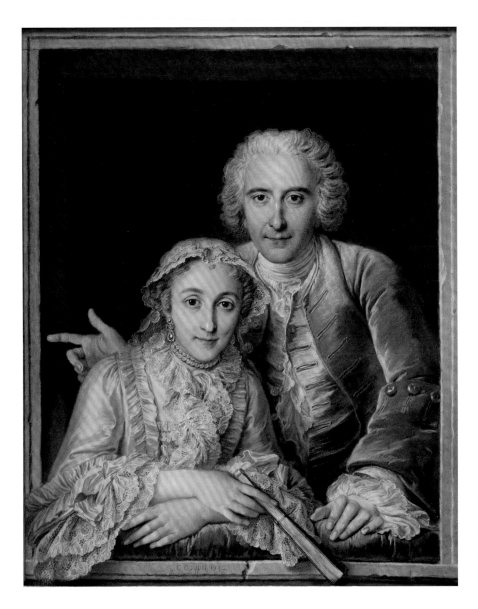

ability would perhaps have caused him some discomfort, it was the younger, upstart artist Jean-Baptiste Perronneau who threatened La Tour's established authority at the next Salon in 1747, prompting him, as we shall see, to re-evaluate his approach to a particular portrait. His reaction also took a less constructive form, however: Perronneau's precocious talent so enraged La Tour that he reputedly set about to defame and outshine his rival in any way he could, ultimately driving him from the capital and forcing him to seek his fortunes elsewhere.[13] In the short term, though, we must turn to one of the many works shown at the Salon of 1747, La Tour's formal portrait of the sculptor Jean-

Baptiste Lemoyne (1747; Georges Dormeuil collection, Paris), "Capped with a wig and decorated with a ruffle."[14] A curiosity that came to light recently is that a second, reworked portrait of Lemoyne, which La Tour exhibited in the Salon of 1763, actually appears to have been made at the same time as the first. This later, unfinished portrait (fig. 8) is extremely direct, and—as a manuscript note on the Salon of 1763 suggests, "The portrait of the celebrated sculptor M. Lemoine, represented as one would see him ordinarily in his study, that is to say in the disarray of a very busy man."[15] Indeed, its unfinished quality, which shows the artist in his studio attire and sparkling with energy, may

FIGURE 8. Maurice-Quentin de La Tour. *Portrait of Jean-Baptiste Lemoyne*, 1763. Pastel on blue laid paper, laid down on canvas, stretched on wood stretcher; 47 x 39 cm (18 ¹/₂ x 15 ³/₈ in.). Musée du Louvre, Paris, A1136.

FIGURE 9. Jean-Baptiste Perronneau (French, 1715–1783). *Portrait of Jean-Baptiste-Antoine Lemoyne*, 1747. Pastel on blue laid paper, laid down on fabric, stretched on wood stretcher; 45.2 x 37.4 cm (17 ¹/₄ x 14 ³/₄ in.). Regenstein Collection, 1995.283.

owe its inspiration to Perronneau's startling depiction of the sculptor's son Jean-Baptiste-Antoine (fig. 9), also shown in the Salon of 1747. Indeed, juxtaposing these two works suggests how Perronneau's refreshingly honest portrayal constituted a hitherto unacknowledged influence on La Tour, eleven years his senior.

As with Boucher's appealing pastel of a boy (fig. 6), Perronneau's bold idealization of youth in the portrait of Le Moyne's five-year-old son must have captivated the public when it was shown in the Salon of 1747. If Carriera was the first to use décolletage to enhance her feminine subjects and seduce her viewers, Perronneau found the equivalent in the appealing, hitherto underexplored genre of juvenile portraiture. Like Rosalba, he has adhered to a light, largely "pastel" palette, without his later trademark greenish cast; rather than imitating her vaporous evenness, however, he has infused the energetic youngster with bold strokes of pure color that anticipate the later work of Jean-Siméon Chardin.[16]

La Tour has been considered the greatest pastel portraitist in eighteenth-century France because, above all, he was interested in the psychology of his models and tried to grasp the essence of each personality with spirit and great technical mastery. The peak of his career bridged the middle of the century, and in 1746 he was fully accepted as a member of the academy as "a painter of pastel portraits"; unlike other gifted pastellists of his day, including Perronneau and, later, Chardin, he did no work in oil. His reputation as a virtuoso portraitist soon opened the doors of many princely and aristocratic homes to him, and in 1750 he was named Painter to the King. Among La Tour's most renowned pastels, and a perfect introduction to his artistic ability (and personal irascibility) at the height of his powers, is a pair of portraits of his friend Jean-Joseph Cassanéa de Mondonville and his wife. Mondonville was a virtuoso violinist and composer who had achieved success with both his motets and theater music and also occupied the important posts of *sous-maître* in the Royal Chapel and

FIGURE 10. Maurice-Quentin de La
Tour. *Portrait of Madame Anne-Jeanne
Cassanéa de Mondonville*, c. 1752. Pastel
on blue-gray laid paper, laid down on
canvas and wrapped around a strainer;
66 x 55 cm (26 x 21 ⅝ in.). Charles H. and
Mary F. S. Worcester Collection, 2001.53.

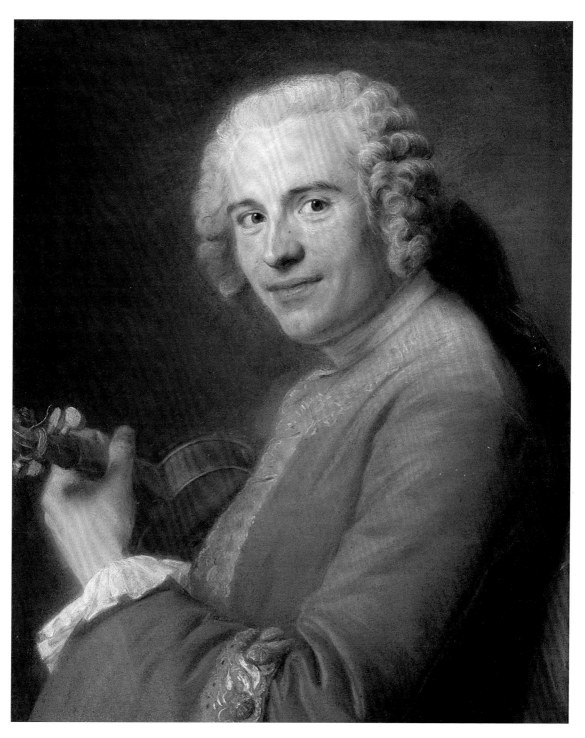

FIGURE 11. Maurice-Quentin de La Tour.
*Portrait of Jean-Joseph Cassanéa de
Mondonville*, 1746/47. Pastel on blue-
gray laid paper, laid down on board;
61.2 x 49.4 cm (24 ¹/₈ x 19 ¹/₂ in.).
Charles H. and Mary F. S. Worcester
Collection, 2001.52.

FIGURE 12. Maurice-Quentin de La Tour. *Portrait of M. Louis de Silvestre*, c. 1753. Black and white chalks with traces of blue and red pastels on greenish brown paper; 30 x 25 cm (11 13/16 x 9 7/8 in.). Gift of the Joseph and Helen Regenstein Foundation, 1958.543.

FIGURE 13. Maurice-Quentin de La Tour. *Portrait of M. Louis de Silvestre*, c. 1753. Pastel on paper; 63 x 51 cm (24 3/4 x 20 1/8 in.). Musée Antoine-Lécuyer, Saint-Quentin, LT 2.

director of the Orchestra of the Spiritual Concert.[17] In 1746 or 1747, at the time that La Tour made his portrait, he knew the composer well, as he frequented his salon.[18] One can thus appreciate the sympathetic cast to this "instantaneous" image of the musician (fig. 11), who tunes his violin and listens to the sound of the instrument. Along with La Tour's portrait of Lemoyne *père* (and Perronneau's of Lemoyne *fils*), this work appeared in the Salon of 1747, the same year that Mondonville married Anne-Jeanne Boucon, the daughter of a great art collector and herself a pupil of Rameau.[19] Some time later, Madame de Mondonville, a talented musician and artist in her own right, apparently asked the artist to make her likeness as well. As this pastel (fig. 10) was shown in the Salon of 1753, it must have been made between the years 1747 and 1753. Praised by the contemporary critic Pierre Estève as "astonishing for its resemblance," the portrait shows the sitter leaning on her instrument, which holds a score of her *Pieces for the Harpsichord*.[20] If we are to believe the great eighteenth-century collector Pierre-Jean Mariette, La Tour created

this work in one sitting and had a falling out with the Mondonvilles, who thought that he would allow them to pay the modest sum of twenty-five *louis* for the portrait instead of his usual 1,200 *livres*:

[La Tour] began to no longer recognize his friend, when it was a question of these portraits. . . . Madame de Mondonville, who joined to the taste for music that of painting, in which she herself sometimes worked, also wanted to have her portrait; but before anything was started on, she vowed to him that she had only twenty-five *louis* to spend. Thereupon, M. de Latour made her sit down, and made a portrait that pleased everyone. He enchanted Madame de Mondonville, who, without losing a moment, drew the money from her purse, and putting it in a box under some sugared almonds, sent it to the painter. M. de Latour looked at the almonds and sent back the money. Madame de Mondonville imagined in this game a galant gesture, and that, not having another explanation since the

original proposition, that M. de Latour wanted to make a present to her of the portrait; and, as she did not want to yield to him in this generosity, she sent to him a silver plate that she noticed was missing from his buffet, and for which she paid thirty *louis*. The new present . . . was sent back, and Madame de Mondonville learned that M. de Latour had placed on his portrait the ordinary tax of 1200 *livres*, and that he added that he had no respect for people who did not think as he did on the accounts of fools (*Bouffons*) whose music and comic representations divided Paris at the moment [all the connoisseurs, among whose number Latour counted himself].[21]

Despite the discord that accompanied their creation, the resonance of these two pendant pastels is quite fortuitous.[22] Although La Tour did not conceive them as a pair from the beginning, they illustrate quite candidly the affection and familiarity the artist held for Mondonville and the challenge presented by his more difficult wife. The artist vividly expressed the couple's varied temperaments, and his use of different techniques suggests his increasing mastery of the medium soon after his acceptance into the academy. In his rendering of Mondonville, for example, La Tour registered his familiarity with his subject by posing him at an angle that hides his violin, adding a sense of informality and intimacy. Mondonville is not erect but relaxed, leaning toward the artist in a way that de-emphasizes his costume and his rank. He appears eminently likeable, elegant but understated. His wife, however, is turned forward to display La Tour's virtuoso handling of many different materials and textures—brocade, ivory, fur, lace, parchment, and satin. This piece was surely done in the early 1750s, when the artist was creating his masterpiece of female portraiture, the full-scale pastel of Madame de Pompadour (Musée du Louvre, Paris), which undoubtedly inspired this ambitious work.[23]

As mentioned earlier, La Tour exhibited this portrait in the Salon of 1753, at around the time he finished his *Portrait of Louis de Silvestre*, for which the Art Institute has a preliminary study. The preparatory drawing (fig. 12) shows the sitter from an angle, while the final pastel (fig. 13) depicts him frontally, standing before an easel in his studio, wearing a dressing gown that is decorated with elegant embroidery and every inch the equal of Madame de Mondonville's finery. Despite his informal attire, Silvestre had just attained a very high rank: after many years working in Saxony and Poland as First Painter to August II and director of the Malerakademie

FIGURE 14. Maurice-Quentin de La Tour. *Portrait of Claude-Charles Deschamps*, 1779. Pastel on tan laid paper, laid down on cream laid paper; 31.7 x 23.3 cm (12 1/2 x 9 3/16 in.). Gift of Dorothy Braude Edinburg to the Harry B. and Bessie K. Braude Memorial Collection, 1998.115.

in Dresden, he had returned to France in 1748, and, upon the death of Coypel in 1752, was appointed director of the Royal Academy. It is very instructive to see the kind of preparatory drawing that La Tour made for his pastels, which clearly were not as spontaneous as he would have viewers believe. While pastel had the advantage, often taken by La Tour, of being easily retouched, what is less apparent to the casual eye is the amount of drawn study that went into each composition. Using a colored paper as a middle ground, the artist would use colored chalks to define the structure, focusing on the eyes and the mouth, with white chalk accents to capture the highlights.

While, as we have seen, a number of La Tour's works in the Art Institute offer us access to incidents in his public career, rarely do we get a glimpse into his private life. Nonetheless, his family, and Saint-Quentin, the city of his birth, clearly remained important to the artist, who returned home to Picardie in 1784 when mental problems made it

FIGURE 15. Jean-Siméon Chardin (French, 1699–1779). *Self-Portrait with a Visor*, c. 1776. Pastel on blue laid paper, mounted on canvas; 45.7 x 37.4 cm (18 x 14 ¾ in.). Clarence Buckingham Collection and the Harold Joachim Memorial Fund, 1984.61.

difficult for him to continue his work.[24] The latest pastel in the museum's array of La Tours, the *Portrait of Claude-Charles Deschamps* (fig. 14), speaks to these ties. This compelling likeness is of the artist's cousin, the Canon of Laon, whom he named in his will of October 1768.[25] In the same year, La Tour made a larger pastel portrait of Deschamps (Musée du Louvre, Paris) that contains an inscription on the verso describing the subject as sixty-nine years of age.[26] The artist may have created the Art Institute's smaller, 1779 version in order to affirm his allegiance to his cousin at another important moment in the life of the family, since Deschamps made his own will on August 20 of that year and died soon thereafter. In this work, La Tour reveals an amazing intimacy

and warmth toward his subject, undoubtedly reflecting deep familial bonds. This small-scale drawing was clearly made for private enjoyment rather than public exposure; rather than elevating his cousin's rank, La Tour has shown the canon's sense of humor and humanity.[27] La Tour is reputed to have claimed, "I penetrate into the depths of my subjects without their knowing it, and capture them whole."[28] With this small keepsake, he probably tried to do just that.

The alpha and the omega of the Art Institute's series of French pastels are Jean-Siméon Chardin's portraits of himself and his wife. It was the latter (fig. 16), purchased in 1962, which inspired the museum's acquisition of a string of important pastel head studies. When the former (fig. 15)

became available in 1984, the chance to reunite these two pendants re-ignited the museum's desire to build a first-rate, representative collection of pastels. These vivacious works are full-scale replicas of pastels now in the Louvre, dated 1775 and shown in the Salon of that year; they show both greater freedom and intimacy than the first versions, which seems fitting, since Chardin probably made the pair for his family.[29] From an art-historical point of view, these rare and wondrous pictures are significant departures from what came before. In their sober, forthright, informal portrayal of their subjects and in the raw, unblended layering of multicolored pastels, they represent a new approach to the medium, very different from the vaporous chalks of Rosalba or the extraordinary textures and velvety surfaces of La Tour.

Surprising in their candor and directness, and abstracting in their representations of the artist's slightly absurd studio attire and his wife's modest, middle-class garments, these portraits represent the antithesis of the confections made by Rosalba and the French artists who followed in her footsteps. With very little stumping or elaborate effects, Chardin—who rarely drew—layered his rich pastel lines like thick impasto on the paper. His is an art of no nonsense, where line and color are one. In his hands, the art of pastel seems to be as straightforward a medium as the colored chalks used by Dumonstier, Lagneau, and Watteau, and to bid adieu to the ancien régime, standing braced for the Revolution.

FIGURE 16. Jean-Siméon Chardin. *Portrait of Madame Chardin*, 1776. Pastel on blue paper, mounted on canvas; 45.5 x 37.5 cm (17 7/8 x 14 3/4 in.). Restricted gift of the Joseph and Helen Regenstein Foundation, 1962.137.

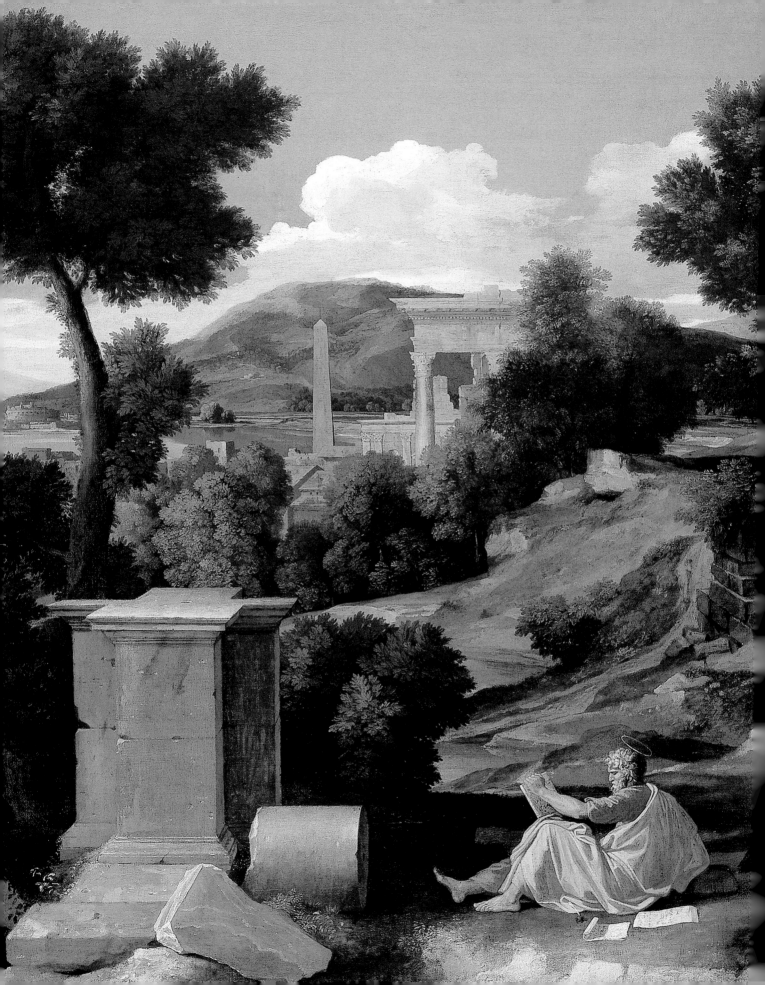

Notes

Feinberg, *A Brief History of the Old Masters in the Art Institute of Chicago*, pp. 6–23.

I wish to thank Dorota Chudzicka, especially, as well as Dr. John E. Gedo, Suzanne Folds McCullagh, and Bart Ryckbosch for their kind assistance in the preparation of this article.

1. For more on Ryerson's collecting and that of other early Art Institute patrons, see Martha Wolff, "Introduction," in Christopher Lloyd et al., *Italian Paintings before 1600 in The Art Institute of Chicago: A Catalogue of the Collection*, ed. Martha Wolff (Art Institute of Chicago/Princeton University Press, 1993), pp. xi–xvi. See also Linda A. Phipps, "The 1893 Art Institute Building and the 'Paris of America': Aspirations of Patrons and Architects in Late Nineteenth-Century Chicago," *Art Institute of Chicago Museum Studies* 14, 1 (1988), pp. 28–45; and Ellis Waterhouse, "Earlier Paintings in the Earlier Years of the Art Institute: The Role of the Private Collectors," *Art Institute of Chicago Museum Studies* 10 (1983), pp. 79–91.

2. For an illustration of *Portrait of an Artist*, now believed to be by a follower of Hals, see Frederick A. Sweet, "Great Chicago Collectors," *Apollo* 84, 55 (Sept. 1966), p. 193, fig. 10.

3. Notable among these works were Casper Netscher's *Lady before a Mirror*, Jan van Goyen's *Fishing Boats off an Estuary*, and Jan van de Capelle's *Fishing Boats in a Calm*. For more on these works, see Marjorie E. Wiesman, *Caspar Netscher and Late Seventeenth-Century Dutch Painting*, Aetas aurea 16 (Doornspijk: Davaco, 2002), pl. 64; Hans-Ulrich Beck, *Jan van Goyen, 1596–1679* (Amsterdam: Van Gendt, 1973), vol. 2, cat. 849; and Margarita Russell, *Jan van de Capelle, 1624/26–1679* (Leigh-on-Sea; F. Lewis, 1975), p. 365, ill. no. 8.

4. For more on the works by Perugino, see "Four *Predella* Panels with Scenes from the Life of Christ," in Lloyd et al. (note 1), pp. 190–96.

5. For more on these works by Robert, see "Four Architectural Caprices for the Château de Mereville," in Susan Wise and Malcolm Warner, *French and British Paintings from 1600 to 1800 in The Art Institute of Chicago: A Catalogue of the Collection*, ed. Larry J. Feinberg and Martha Wolff (Art Institute of Chicago/Princeton University Press, 1996), pp. 127–36.

6. For more on Reynolds's painting, see Malcolm Warner, "The Sources and Meaning of Reynolds's *Lady Sarah Bunbury Sacrificing to the Graces*," *Art Institute of Chicago Museum Studies* 15, 1 (1989), pp. 6–19; and "Lady Sarah Bunbury Sacrificing to the Graces," in Wise and Warner (note 5), pp. 276–82.

7. For more on this painting, see Art Institute of Chicago, *Paintings in the Art Institute of Chicago: A Catalogue of the Picture Collection* (Art Institute of Chicago, 1961), pp. 365, 188 ill.

8. For more on the Tiepolos, see Hylton A. Thomas, "Tasso and Tiepolo in Chicago," *Art Institute of Chicago Museum Studies* 4 (1970), pp. 26–48; for the Batoni, see Anthony M. Clark, *Pompeo Batoni: A Complete Catalogue of His Works with an Introductory Text* (Phaidon, 1985), cat. 216, fig. 201; for the Goya, see José Luis Morales y Martín, *Goya: A Catalogue of His*

OPPOSITE: Detail of *Landscape with Saint John on Patmos* (p. 17, fig. 2).

Paintings, trans. Muriel Feiner (Zaragoza: Real Academia de Nobles y Bellas Artes de San Luis, 1997), cat. 165.

9. For more on the history of the Antiquarian Society, including profiles of Robert Allerton and Mary Blair, see Celia Hilliard, "'Higher Things': Remembering the Early Antiquarians," *Art Institute of Chicago Museum Studies* 28, 2 (2002), pp. 6–21.

10. For more on Kate Buckingham, see Christina M. Nielsen, "'To Step into Another World': Building a Medieval Collection at the Art Institute of Chicago," *Art Institute of Chicago Museum Studies* 30, 2 (2004), pp. 11–13.

11. For more on the Art Institute's works by Apollonio di Giovanni and his workshop, see Lloyd et al. (note 1), pp. 6–17; for Ugolino di Nerio's *Virgin and Child Enthroned with Saints Peter, Paul, John the Baptist, and a Donor,* see ibid., pp. 258–61. For Lorenzo Monaco's *Crucifixion,* see ibid., pp. 85–89; and *Art Institute of Chicago Museum Studies* 30, 2 (note 10), cat. 32. For more on Ryerson's collection in general, see *Martin A. Ryerson Collection of Paintings and Sculpture: XIII to XVIII Century: Loaned to the Art Institute of Chicago* (Art Institute of Chicago, 1926).

12. For more on Van der Weyden's *Jean Gros* and Hey's *Saint John the Evangelist,* see *Northern European and Spanish Paintings before 1600 in the Art Institute of Chicago,* ed. Martha Wolff (Art Institute of Chicago/Yale University Press, forthcoming, 2007).

13. For Bassano's *Diana and Actaeon,* see Lloyd et al. (note 1), pp. 21–24; for Roberti's *Virgin and Child,* see ibid., pp. 209–12; for Moroni's *Gian Lodovico Madruzzo,* see ibid., pp. 165–71.

14. For the Manfredi, see Art Institute of Chicago, *Treasures from The Art Institute of Chicago* (Art Institute of Chicago/Hudson Hills Press, 2000), p. 105. For the Jordaens and the Snyders, see *Art Institute of Chicago Annual Report 1990–91* (Chicago, 1991), p. 2; and *Treasures from The Art Institute of Chicago* (above), p. 107.

15. For more on Barnard and the Guelph Treasure exhibition in Chicago, see Nielsen (note 10), pp. 13–14.

16. For Parmigianino's *Old Shepherd Leaning on a Staff,* see Suzanne Folds McCullagh and Laura M. Giles, *Italian Drawings before 1600 in The Art Institute of Chicago: A Catalogue of the Collection* (Art Institute of Chicago/Princeton University Press, 1997), cat. 220.

17. For more on these works, see *Art Institute of Chicago Museum Studies* 30, 2 (note 10), cats. 28, 49.

18. For Badile's *Bust of a Young Man in Profile* and Pisanello's *Sketches of the Emperor John VIII Palaeologus, a Monk, and a Scabbard,* see McCullagh and Giles (note 16), cats. 6, 250.

19. For more on Regenstein's acquisitions for the Art Institute, see Harold Joachim, *The Helen Regenstein Collection of European Drawings: Catalogue* (Art Institute of Chicago, 1974); and Suzanne Folds McCullagh, "'A Lasting Monument': The Regenstein Collection at the Art Institute of Chicago," *Art Institute of Chicago Museum Studies* 26, 1 (2000), pp. 5–13.

20. For more on Chadbourne and her collecting interests, particularly in American art, see Judith A. Barter, "American Art in the 'Great Grey City': The Evolution of a Collection at the Art Institute of Chicago," in Judith A. Barter et al., *American Arts at The Art Institute of Chicago: From Colonial Times to World War I* (Art Institute of Chicago/Hudson Hills, 1998), pp. 31–32.

21. For more on the history of the Art Institute's textile collection, see Christa C. Mayer Thurman, "Introduction," in Christa C. Mayer Thurman, *Textiles in the Art Institute of Chicago* (Art Institute of Chicago, 1992), pp. 6–8.

22. For *The Crucifixion,* see Lloyd et al. (note 1), pp. 146–51; for the Poussin, see Wise and Warner (note 5), pp. 117–24.

23. For the Watteau, see Wise and Warner (note 5), pp. 159–69.

24. For more on Harding and his collection, see Walter J. Karcheski, *Arms and Armor in the Art Institute of Chicago* (Art Institute of Chicago/Bullfinch, 1995), pp. 8–16; and Judith A. Barter, *Window on the West: Chicago and the Art of the New Frontier, 1890–1940* (Art Institute of Chicago/Hudson Hills, 2003), chap. 3.

25. For these works and other early paintings in Harding's collection, see Wolff (note 12).

26. For Chadbourne's eighteenth-century English paintings, see Wise and Warner (note 5), pp. 198–200, 204–12.

27. For these three works, see Lloyd et al. (note 1), pp. 243–46, 67–72, 25–28.

28. For the former, see ibid., pp. 146–52; for the latter, *Art Institute of Chicago Museum Studies* 28, 2 (note 9), cat. 40.

29. For Wtewael's *Battle between the Gods and the Titans,* see *Master Paintings in The Art Institute of Chicago* (Art Institute of Chicago, 1999), p. 23; for Cuyp's *View of Vianen with Herdsman and Cattle,* see Stephen Reiss, *Aelbert Cuyp* (New York Graphic Society, 1975), p. 54. Potter's *Two Cows and a Young Bull beside a Fence in a Meadow* is published in *Art Institute of Chicago Museum Studies* 30, 1 (2004), pp. 60–61. For Baglione's *Ecstacy of Saint Francis,* see ibid., pp. 56–57; the Giordano is published in Larry J. Feinberg, "Luca Giordano's *Abduction of the Sabine Women," Art Institute of Chicago Museum Studies* 21, 1 (1995), pp. 38–47; and Ribera's *Saint Peter Penitent* in *Art Institute of Chicago Museum Studies* 30, 1 (above), pp. 58–59.

30. Guardi's *Garden of the Palazzo Contarini dal Zaffo* is published in *Art Institute of Chicago Annual Report 1990–91* (note 14); for Wright's *Gulf of Salerno,* see *Art Institute of Chicago Annual Report 2002–03* (Chicago, 2003).

31. For more on the Art Institute's collection of Flemish tapestries in particular, see Christa C. Mayer Thurman and Koenraad Brosens, "Flemish Tapestries in the Collection of The Art Institute of Chicago," in *Flemish Tapestry in European and American Collections: Studies in Honour of Guy Delmarcel,* Studies in Western Tapestry 1, ed. Koenraad Brosens (Brepols, 2003), pp. 171–84.

32. For the Florentine orphrey bands and fragments, see *Art Institute of Chicago Museum Studies* 29, 2 (2003), pp. 20–21. The *Stafford Chasuble* and *Stafford Altar Frontal* remain unpublished.

33. For Algardi's *Crucifix,* see *Art Institute of Chicago Museum Studies* 32, 1 (2005), pp. 50–51; for Tacca's *Bireno and Olimpia, Art Institute of Chicago Museum Studies* 29, 2 (note 32), pp. 60–61; for the Parodi, see ibid., pp. 58–59; for the Kienle, ibid., pp. 56–57; for the Houdon, *Art Institute of Chicago Museum Studies* 28, 2 (note 9), pp. 86–87. The Deare is unpublished.

34. For Bandinelli's *First Family before a Shelter,* see McCullagh and Giles (note 16), cat. 11; for the Castiglione, see Sue Welsh Reed, "Giovanni Benedetto Castiglione's *God Creating Adam*: The First Masterpiece in the Monotype Medium," *Art Institute of Chicago Museum Studies* 17, 1 (1991), pp. 66–73.

35. These exhibitions were *Gifts of a Lifetime* (1998–99), *Drawn to Form* (1999), and *Drawings in Dialogue: Old Master through Modern; The Harry B. and Bessie K. Braude Memorial Collection* (2006). For the Romano, see "Daedalus and Icarus," in *Drawings in Dialogue: Old Master through Modern; The Harry B. and Bessie K. Braude Memorial Collection,* exh. cat. (Art Institute of Chicago/Yale University Press, 2006), cat. 3; for Watteau's *Three Studies of a Gentleman,* see ibid., cat. 25; for Boucher's *Farm Courtyard* and *Venus Asking Vulcan for Arms for Aeneas,* see ibid., cats. 29–30.

36. For Correggio's *Saint Benedict Gesturing to the Left: Study for the Coronation of the Virgin,* see McCullagh and Giles (note 16), cat. 122. The Hilliard's Oudry, *Lattice Work and Reflecting Pool at Arcueil,* is unpublished. For more on Stradano's *Men Hunting Ibexes with Hounds,* see Alessandra Baroni Vannucci, *Jan Van Der Straet detto Giovanni Stradano,* Archivi arti anticha (Milan: Jandi Sapi, 1997), cat. 326; for Saint-Aubin's *The Genius of Painting* and *Woman Seated Holding a Cat on Her Knees,* see Émile Dacier, *Gabriel de Saint-Aubin: Peintre, dessinateur et graveur, 1724–1780* (Paris: G. van Oest, 1929–31), vol. 2, cats. 94, 342.

37. For a thorough catalogue of this collection, see *Art Institute of Chicago Museum Studies* 25, 2 (2000).

Boucher, "War in Heaven": Saint Michael and the Devil, pp. 24–31.
I wish to thank Marjorie Trusted and Paul Williamson for their advice in the preparation of this article.

1. For more on the *Corpus of Christ* and the *Reliquary Bust of Saint Margaret of Antioch*, see entries by Christina M. Nielsen in *Art Institute of Chicago Museum Studies* 30, 2 (2004), cats. 37, 56.

2. The following is based upon the introductory essay by Marjorie Trusted in idem, *Spanish Sculpture: Catalogue of the Post-Medieval Spanish Sculpture in Wood, Terracotta, Alabaster, Marble, Stone, Lead, and Jet in the Victoria and Albert Museum, London* (Victoria and Albert Museum, 1996), pp. 1–17.

3. Richard Ford, *A Handbook for Travellers in Spain and Readers at Home* (1845; repr., University of Southern Illinois Press, 1966), pp. 169–70.

4. See especially Gridley McKim-Smith, "Spanish Polychrome Sculpture and Its Critical Misfortunes," in *Spanish Polychrome Sculpture, 1500-1800, in United States Collections*, ed. Suzanne L. Stratton, exh. cat. (New York: Spanish Institute, 1993), pp. 13–31.

5. Quoted in Trusted (note 2), p. 8.

6. For the following paragraphs, see Theodore Müller, *Sculpture in the Netherlands, Germany, France, and Spain, 1400–1500*, Pelican History of Art 25 (Penguin, 1966), pp. 142–54. For a more recent and somewhat skeptical view of the term "Hispano-Flemish," see the articles by Dagmar Eichberger, Joaquin Yarza Luaces, Pilar Silva Maroto, and Jacques Paviot in *The Age of Van Eyck: The Mediterranean World and Early Netherlandish Painting, 1430–1530*, ed. Till-Holger Bochert, exh. cat. (Thames and Hudson, 2002).

7. For more on the *Miraflores Triptych*, see Bochert (note 6), p. 145, fig. 131.

8. Quoted in Paul Williamson, *Netherlandish Sculpture, 1450–1550* (Victoria and Albert Museum, 2002), p. 21.

9. On the iconography of Saint Michael, see Engelbert Kirschbaum, ed., *Lexikon der Christlichen Ikonographie* (Rome: Herder, 1968–76), vol. 3, cols. 255–65.

10. Dorothee Heim, *Ein Hauptwerk der Sevillaner Spätgotik: Der Erzengel Michael von Pedro Millán* (Munich: privately printed, 2002).

11. Ibid., pp. 19–20.

12. Müller (note 6), pp. 147–48. For more on the maiolica roundels of saints Cosmas and Damian, and the statue of Saint James the Greater, see M. Fernanda Moron de Castro, "Pedro Millan," in Jane Turner, ed., *The Dictionary of Art* (Grove, 1996), vol. 21, pp. 604–05.

13. Heim (note 10), pp. 27–35. On Millán's terracotta in London, see Trusted (note 2), cat. 34. Trusted has plausibly identified this work as representing Saint George rather than Saint Michael because there were never any wings, a feature invariably found on images of the latter.

14. For a recent survey of his work, see Holm Bevers, *Meister E.S., ein Oberrheinischer Kupferstecher der Spätgotik*, exh. cat. (Staatliche Graphische Sammlung München, 1986), esp. pp. 7–20.

15. Heim (note 10), pp. 34–35. The engraving is cat. 153 in Musée du Louvre, Cabinet des dessins, *Écoles allemande, des Anciens Pays-Bas, flamande, hollandaise et suisse, Xve–XVIIIe siècles* (Réunion des musées nationaux, 1988); see also ibid., cats. 67–69.

16. Heim (note 10), p. 29 and fig. xvi.

17. On tassets, see especially Martin de Riquer, *L'Arnès del Cavaller: Armes i armadures catalanes medievals* (Barcelona: Ediciones Ariel, 1968), pp. 102–03, figs. 150, 168, 219.

18. For a boxwood and silver sculpture of Saint Michael possibly from Catalunya, and with similar armor to the Art Institute's, see Trusted (note 2), cat. 50. For a discussion of the Princeton sculpture, see Stratton (note 4), pp. 80–81.

Feinberg, *Fra Bartolommeo's* Nativity: *A Rediscovered High Renaissance Masterpiece*, pp. 32–43.

I wish to thank Albert Elen, Everett Fahy, John E. Gedo, Rachel Narens, and Martha Wolff for their assistance in the preparation of this article.

1. Enrico Ridolfi, "Notizie sopra varie opere di Fra Bartolommeo da San Marco," *Giornale ligustico di archeologica, storia e belle arti* 5 (1878), p. 122. Other publications that mention *The Nativity* include Vincenzo Fortunato Marchese, *Memorie dei più insigni pittori, scultori e architetti domenicani* (Bologna: G. Romagnoli, 1879), vol. 2, p. 177; Fritz Knapp, *Fra Bartolommeo della Porta und die Schule von San Marco* (Halle: Knapp, 1903), p. 271; Hans von der Gabelentz, *Fra Bartolommeo und die Florentiner Renaissance* (Leipzig: K. W. Hiersemann, 1922), cat. 3; and Janet Cox-Rearick, *The Collection of Francis I: Royal Treasures* (Harry N. Abrams, 1996), p. 168, under cat. V-2. Records indicate that Fra Bartolommeo was paid only twenty and forty *ducats* each for two very large altarpieces; see Knapp, above, p. 274. Another useful comparison might be Botticelli's grand *Cestello Annunciation* (1490; Galleria degli Uffizi, Florence), for which he was paid thirty *ducats*.

2. Giorgio Vasari, *Le Vite de' più eccellenti pittori, scultori e architettori*, ed. Gaetano Milanesi (Florence: G. C. Sansoni, 1906), vol. 4, pp. 180–84.

3. According to the account book, "1507—From Domenico Perini on the 16th [of April] the Prior received 30 gold *florins* in payment for a small picture of the Manger or rather the Nativity, which was painted by our brother Fra Bartolommeo and sold by him" (1507—Da Domenico Perini a di 16 detto [aprile] fioreni 30 larghi d'oro in oro recò il soppriore disse per pagamento d'un quadretto dentrovi un Presepio ovvero Natività del Nostro Signore, el quale aveva dipinto Fra Bartolommeo nostro frate e a lui venduto); transcribed in Ridolfi (note 1), p. 122. In a list of all of the pictures painted by Fra Bartolommeo in the monastery of San Marco, written by Fra Bartolommeo Cavalcanti on Dec. 3, 1516, is the following description: "Also [he] painted a little picture of about half a *braccio*, which was a Nativity [given] to Domenico Perini for [export to] France—[from whom was received?] XXX ducats, as appears in said book" (Item dipinse un quadretto circa d'un mezzo braccio, nel quale era una Natività a Domenicho Perini per in Francia—ébbene duc. XXX, come appare al detto libro). The height of the Chicago painting corresponds roughly to that of the Nativity mentioned by Cavalcanti—a "mezzo braccio" or about 30 cm (11 ¹³/₁₆ in.). The list was preserved in the Biblioteca Mediceo-Laurenziana, Florence (now Archivio di Stato) as Manuscript San Marco 903, Ricordanze B, fol. 127, when transcribed in Marchese (note 1), p. 177. These statements were reiterated by the so-called Anonimo Gaddiano, who wrote in around 1540 that Fra Bartolommeo "painted two very beautiful panels that were sent to France" (dipinse dua tavole molto belle che furon mandata in Francia); quoted in Cox-Rearick (note 1), pp. 167–68. Because the *Noli me tangere* was, from the early seventeenth century on, continuously recorded in the inventory of the royal château at Fontainebleau, it has been suggested (but not confirmed) that both pictures entered the collection of Louis XII upon arriving in France. While the *Noli me tangere* remained in the royal collection before passing to the Musée du Louvre, *The Nativity* was for some time in private hands. The work was in the Bedeneau de Buxerolles collection in Poitou, then, by descent, to the Tabarly collection in Blois, and subsequently in the possession of Pierre Landry in Paris by 1955. His heirs sold the picture on the London art market in 2001.

4. Eventually Fra Bartolommeo sent at least three other pictures to the French court: a *Saint Sebastian* (1514/15; destroyed), a *Dream of Savonarola* (1514/15; lost), and an *Incarnation of Christ with Saints* (1515; Musée du Louvre); see Cox-Rearick (note 1), cats. V-3–5.

5. See Henri Zerner, *L'Art de la Renaissance en France: L'Invention du classicisme* (Flammarion, 1996), chap. 1; François Avril, ed., *Jean Fouquet: Peintre et enlumineur du XVe siècle*, exh. cat. (Bibliothèque nationale du France/Hazan, 2003), esp. cat. 24; and Raymond Limousin, *Jean Bourdichon, peintre & enlumineur: Son atelier et son école* (Lyon: Presses académiques, 1954), esp. figs. 24, 26, 153, 182.

6. For Leonardo's *Adoration* and more on the use of the "new tree" symbol and the theme of revelation, see Larry J. Feinberg, "Sight Unseen: Vision and Perception in Leonardo's Madonnas," *Apollo* 160, 509 (July 2004), pp. 33–34, fig. 6. For the tradition of Christ as the Tree of Life, see Romuald Bauerreiss, *Arbor Vitae: der "Lebensbaum" und seine Verwendung in Liturgie, Kunst und Brauchtum des Abendlandes* (Munich: Neuer Filser-Verlag, 1938); and Frederick Hartt, "Lignum Vitae in Medio Paradisi: The Stanza d'Eliodoro and the Sistine Ceiling," *Art Bulletin* 32, 2 (June 1950), pp. 115, 129–45.

7. For a discussion of *The Mystic Nativity,* see Richard Lightbown, *Sandro Botticelli* (London: Elek, 1978), vol. 1, pp. 134–38; vol. 2, cat. B90. In its composition and retinue of angels, Fra Bartolommeo's work also recalls an *Adoration* of the mid-1450s (Galleria degli Uffizi, Florence) executed by Botticelli's teacher Fra Filippo Lippi and a Nativity fresco by Bartolommeo di Giovanni (1492/93–96; Borgia Apartments, Sala dei Misteri, Vatican); for more on these works, see Jeffrey Ruda, *Fra Filippo Lippi: Life and Work with a Complete Catalogue* (Phaidon, 1993), pl. 124, cat. 48; and Everett Fahy, *Some Followers of Domenico Ghirlandajo* (Garland, 1976), cat. 63, fig. 33.

8. For Savonarolan influence on the picture, see Herbert P. Horne, *Botticelli, Painter of Florence* (1908; repr., Princeton University Press, 1980), pp. 294–301; and Lightbown (note 7), pp. 136–38.

9. Comparable trios of angels holding ribbons and unfurled scrolls are found in paintings of the Nativity by Mariotto Albertinelli, Fra Bartolommeo's professional partner and collaborator, and the little-known Giovan Battista Pistoiese; both works are clearly derived from the Art Institute's picture. Albertinelli's *Nativity* (1506/07; Courtauld Institute Gallery, London) may have been created in Fra Bartolommeo's studio before he had finished his work. Pistoiese, an assistant of Gerino da Pistoia, executed his *Nativity* (1520/30, Museo Civico, Pistoia) some years after Fra Bartolommeo's picture had traveled to France and so must have either seen a now-lost replica or had access to a surviving cartoon. For more on the former picture, see Ludovico Borgo, *The Works of Mariotto Albertinelli* (Garland, 1976), cat. 12, fig. 19; for the latter, see Josephine Rogers Mariotti, "'Giovan Battista Pistoiese,' Allievo di Gerino da Pistoia," in *Fra Paolino e la pittura a Pistoia nel primo '500,* ed. Chiara d'Afflitto, Franca Falletti, and Andrea Muzzi, exh. cat. (Florence: Giunta regionale Toscana/ Venice: Marsilio, 1996), cat. 33. Fra Bartolommeo's angels and composition are also echoed in paintings of the Nativity by Ridolfo Ghirlandaio, Franciabigio, and attributed to Tommaso di Stefano; see Bernard Berenson, *Italian Pictures of the Renaissance: A List of the Principal Artists and Their Works, with an Index of Places; Florentine School* (Phaidon, 1963), vol. 2, cats. 1286–87, 1357; and Susan Regan McKillop, *Franciabigio,* California Studies in the History of Art 16 (University of California Press, 1974), pp. 130–31, cat. 8, fig. 19.

10. Gyrfalcons and peregrine falcons were the hunting birds of choice in the Renaissance; both are colored in this way.

11. Christian Antoine de Chamerlat, *Falconry and Art* (Sotheby's Publications, 1987), p. 56. That falconry is depicted rather than some other kind of hunt is also indicated by the absence of hounds and weapons.

12. Ibid., p. 57.

13. Perhaps the most famous Florentine paintings that include reference to falconry are Gentile da Fabriano's *Adoration of the Magi* (1423; Galleria degli Uffizi), in which a falconer releases his bird in the distant background; and Benozzo Gozzoli's *Journey of the Magi* (1459–61; west wall, Chapel of the Magi, Palazzo Medici-Riccardi), which shows a falcon presiding over its prey, a hare, in the foreground, while various hunters and hunts animate the background. In Renaissance Italy, the sport of falconry was practiced mainly in the northern courts of the Este and Gonzaga families, who were long allied with the French and, in the sixteenth century, connected through marriage; see Giancarlo Malacarne, *Le Cacce del principe: l'ars venandi nella terra dei Gonzaga* (Modena: Il Bulino, 1998), pp. 57–113.

14. For examples of "brainstorming" sheets by Leonardo and Raphael, see Leonardo's sheet of studies for a Nativity in the Metropolitan Museum of Art, New York; and Raphael's drawings of the Virgin and Child on a famous sheet in the British Museum, London. These are reproduced, respectively, in Carmen C. Bambach, ed., *Leonardo da Vinci, Master Draftsman,* exh. cat. (Metropolitan Museum of Art, 2003), cat. 45; and Eckhart Knab, Erwin Mitsch, and Konrad Oberhuber, *Raphael: die Zeichnungen,* Veröffentlichungen der Albertina 19 (Stuttgart: Urachhaus, 1983), cat. 161.

15. For more on this drawing, see Chris Fischer, *Disegni di Fra Bartolommeo e della sua scuola,* Cataloghi Gabinetto disegni e stampe degli Uffizi 66 (Florence: L. Olschki, 1986), cat. 5.

16. For more on the Louvre drawing (fig. 6 in this essay), see Chris Fischer, *Fra Bartolommeo et son atelier: dessins et peintures des collections francaises,* exh. cat. (Réunion des musées nationaux, 1994), cat. 37. Possibly connected to this work and, ultimately, to the Chicago *Nativity* is a quick, black chalk sketch of a seated male figure and supine infant with arms extended, in the Galleria degli Uffizi (1273Ev). For more on fig. 7, see Fischer (note 15), cat. 19.

17. For more on this drawing, see Fischer (note 16), cat. 41.

18. The first of these drawings (Galleria degli Uffizi) is published in Fischer (note 15), cat. 29; the second (Musée du Louvre) appears in Fischer (note 16), cat. 22.

19. For more on fig. 14, see Fischer (note 16), cat. 28. For fig. 15, see Jacob Bean, *Fifteenth and Sixteenth Century Italian Drawings in the Metropolitan Museum of Art* (Metropolitan Museum of Art, 1982), cat. 25. For the drawing with the townscape (Musée du Louvre) that Fra Bartolommeo reproduced from Dürer's engraving *Hercules at the Crossroads* (1498/99), see Fischer (note 16), cat. 27. For the Dürer print, see Walter L. Strauss, ed., *Albrecht Dürer,* Illustrated Bartsch 10 (New York: Abaris Books), cat. 73. Buildings derived from Dürer's engraving also appear in Fra Bartolommeo's contemporary *Noli me tangere.*

20. I wish to thank Frank Zuccari and Julie Simek of the Art Institute's Department of Conservation for their assistance in interpreting the X-radiograph.

21. See Chris Fischer, *Fra Bartolommeo: Master Draughtsman of the High Renaissance,* exh. cat. (Museum Boijmans Van Beuningen/University of Washington Press, 1990), p. 104, n. 82; and Everett Fahy in Serena Padovani, *L'età di Savonarola: Fra Bartolommeo e la scuola di San Marco,* exh. cat. (Florence: Giunta regionale Toscana/Venice: Marsilio, 1996), cat. 17–17a; the latter offers an illustration of the Peretz picture.

22. Padovani (note 21), cat. 17a.

Turner, *Much of Real Fascination: New Discoveries among the Italian Baroque Drawings in the Art Institute of Chicago,* pp. 44–59.

Thanks to an invitation from Suzanne Folds McCullagh, I was able to spend a blissful week at the Art Institute in the late fall of 2002. My visit was funded by the Community Associates of the Art Institute, to whom I extend my warmest thanks. On Dec. 27, 2002, I sent a copy of my comments on several of the drawings to Ms. McCullagh, which can be found in the files of Department of Prints and Drawings. I later summarized these same findings in a lecture entitled "'Much of Real Fascination': A Survey of the Italian Baroque Drawings in the Art Institute, Chicago," given to an audience of Community Associates and other guests on Apr. 22, 2003. The present article is largely based on that presentation. In addition to Ms. McCullagh, I should also like to thank Lucia Tantardini Lloyd for checking numerous points of information during the final stages of writing. The following have also greatly assisted my research: Kristi Dahm, Jean and Steven Goldman, Susan F. Rossen, Erich Schleier, Harriet K. Stratis, and Martha Tedeschi.

1. Some of these drawings are published in Harold Joachim, with Suzanne Folds McCullagh and Sandra Haller Olsen, *Italian Drawings of the 15th, 16th, and 17th Centuries,* Art Institute of Chicago (University of Chicago Press, 1979), while a smaller selection appears in Harold Joachim and Suzanne Folds McCullagh, *Italian Drawings in the Art Institute of Chicago* (University of Chicago Press, 1979).

2. Hans Tietze, *European Master Drawings in the United States* (New York: J. J. Augustin, 1947), p. ix. Gurley's gift is the source of the great majority of the seventeenth-century Italian drawings in the Art Institute's collection. A good account of the circumstances of this donation is provided in Suzanne Folds McCullagh and Laura M. Giles, *Italian Drawings before 1600 in The Art Institute of Chicago: A Catalogue of the Collection* (Art Institute of Chicago/ Princeton University Press, 1997), pp. ix–x.

3. For more on Deering's collection, see "Drawings from the Charles Deering Collection," *Bulletin of the Art Institute of Chicago* 22, 5 (May 1928), pp. 64–66.

4. There is a loss at the top of the sheet, which was at some point badly repaired with a piece of new, vaguely matching paper substituted for the missing area; there are several abrasions to the surface that affect the legibility of some passages. Thanks to the excellent conservation work undertaken by Harriet K. Stratis and

her staff in the Department of Prints and Drawings, the sheet may now be more easily interpreted. Inscribed on the reverse, in brown ink, in a seventeenth-century hand that may be the artist's, is the dedication "My most worthy lord and patron" (Sig[no]r mio / osservan- / dissimo / patrono). The significance of this inscription is naturally obscure, but it is not impossible that it may be Reni's presentation of his own design to his "patron," either Pope Paul V, Cardinal Scipione Borghese, or one of their respective delegates. According to another, later note on the reverse, the drawing once belonged to Sir Benjamin West, the American history and portrait painter, long resident in London, who was an enthusiastic collector of Old Master drawings. Unfortunately, it has not been possible to identify the drawing precisely among the lots in West's posthumous sales. According to Frits Lugt, these were held in London by Christie's on June 9, 1820, and the following four days (section I of Old Master drawings); and on July 1, 1820, and the following four days (section II of Old Master drawings); see Frits Lugt, *Les Marques de collections de dessins et d'estampes* (Amsterdam: Vereenigde Drukkerijen, 1921), cat. 419. A sale at Sotheby's, London, on May 11, 1836, contained Old Master drawings, including works given to Guido Reni. Unfortunately, in 1820 Christie's evaded a proper description of the items by claiming that "the splendid collection of prints and drawings now offered to public attention is so universally known that any detailed account must be deemed unnecessary"; preface, Christie's sale catalogue (1820), n.pag. The most likely possibility, however, is that the Chicago drawing was included on June 10, 1820 (the second day of the first sale), in lot 106, which was described as "Three ditto [i.e. 'studies in pen and ink'] Guido."

5. For a discussion of Reni's Vatican frescoes, see D. Stephen Pepper: *Guido Reni: L'Opera completa* (Novara: Istituto Geografico de Agostini, 1988), cat. 30, figs. 29A–C.

6. The drawing has long been attributed to Guido Reni's circle, and it has been dismissed in more recent times as a copy; see the pencil note to this effect on the reverse of the old mount in the hand of Erich Schleier, who visited the Art Institute in 1992.

7. The drawing bears the following inscriptions on the reverse: q.s Parmeggiano (in brown ink, in an old hand) and Battista Franco (in graphite).

8. I am grateful to Erich Schleier for his comments on the drawing in his letter to me of Jan. 22, 2006. He conceded the strong case in favor of Lanfranco's authorship while continuing to retain some doubt in the matter.

9. Lanfranco's decoration of the chapel is comprehensively described and illustrated in Ilaria Toesca, "Note sul Lanfranco nella Cappella Buongiovanni in Sant'Agostino di Roma," *Bollettino d'Arte* 44, 4 (Oct.–Dec. 1959), pp. 337–46. The decoration was subsequently discussed by, among other scholars, Erich Schleier in *Disegni di Giovanni Lanfranco (1582–1647)*, exh. cat., Cataloghi Gabinetto disegni e stampe degli Uffizi 59 (Florence: L. Olschki, 1983), cats. IX a–f; and Maria Grazia Bernardini in *Giovanni Lanfranco: Un Pittore barocco tra Parma, Roma e Napoli*, ed. Erich Schleier, exh. cat. (Electa, 2001), cats. 26–28. Bernardini argued for dating the commission to around 1615 rather than 1616, as had been previously thought.

10. For the provenance and bibliography of the Louvre drawing, see Erich Schleier, "Studio per la Vergine dell 'Assunzione' nella cupola della capella Bongiovanni in Sant'Agostino a Roma," in Schleier, ed. (note 9), cat. D 10.

11. "Une Vaghesse qu'on ne trouve dans les Dessins d'aucun autre Maitre"; *vaghesse* is a rendering in French of the Italian *vaghezza*, or charm. Pierre-Jean Mariette, *Description sommaire des dessins des grands maistres d'Italie, des Pays-Bas et de France, du cabinet de feu M. Crozat* (Paris, 1741), p. 57.

12. I first noted that this drawing is by Guercino himself, rather than by a member of his school, on the occasion of "Italian Drawings in the Age of Michelangelo," a symposium held at the Art Institute of Chicago, May 16–18, 1997.

13. For Ludovico Carracci's Vatican painting, see Alessandro Brogi, *Ludovico Carracci: 1559–1619*, Pittori d'Italia 3 (Bologna: Tipoarte, 2001), vol. 1, cat. 20. According to Brogi, it is probably identical with the painting of the subject recorded in the Casa Sturoli, Bologna, shortly after the middle of the eighteenth century.

14. For more on this drawing, see Denis Mahon and David Ekserdjian, *Guercino Drawings from the Collections of Denis Mahon and the Ashmolean Museum*, exh. cat. (Ashmolean Museum, 1986), cat. 10. See also Massimo Pulini, ed., *Guercino as Master Draughtsman: Drawings from the Mahon Collection, the Ashmolean Museum at Oxford, and the City of Cento*, exh. cat. (Cento: Museo Civico, 2005), pp. 76–77.

15. In April 1991, Mario di Giampaolo attributed the drawing enthusiastically to Pietro Faccini (d. 1602), a precocious follower of Annibale Carracci, and some visitors to the collection seem to have been persuaded by this opinion. For a number of scholarly opinions on this piece, see the files of the Department of Prints and Drawings.

16. Luigi Salerno, *Dipinti del Guercino* (Rome: Ugo Bozzi Editore, 1988), cat. 216.

17. Guercino made many drawings from the nude in oiled charcoal, sometimes with the addition of black chalk. For comparison with the Chicago example, see two drawings of the male nude included in David M. Stone, *Guercino, Master Draftsman: Works from North American Collections*, exh. cat. (Cambridge, Mass.: Harvard University Art Museums/Bologna: Nuova Alfa Editoriale, 1991), cats. 64–65. These works are, respectively, in the National Gallery of Art, Washington, D.C., and the collection of Mr. and Mrs. Joseph Henry Grand, St. Louis.

18. For Guido Reni's *Saint Michael the Archangel*, see Pepper (note 5), cat. 145, fig. 135. Reni painted the altarpiece in Bologna before dispatching it to Rome, and Guercino would surely have surely known of the appearance of his rival's composition.

19. The altarpiece (for which see Salerno [note 16], cat. 213) remained in San Biagio, Vicenza, until the suppression of the church in 1797. For further historical particulars on the painting, see Maria Teresa Dirani Mistrorigo, *La Chiesa e il convento di San Biagio nuovo* (Vicenza: Accademia Olympica, 1988), pp. 10, 32–37, 61–62.

20. For example, the drawing was not included in Stone (note 17).

21. The only other candidate is *David and Abigail*, a drawing formerly in the Ellesmere Collection, the present whereabouts of which are unknown; see Sotheby's, London, *Catalogue of the Ellesmere Collection of Drawings by the Carracci and other Bolognese Masters, Collected by Sir Thomas Lawrence*, sale cat. (Sotheby's, July 11, 1972), lot 97, as "Studio of Guercino." This drawing, perhaps intended as a *ricordo* or for an engraving, corresponds precisely, apart from the landscape background, to the composition of Guercino's 1636 painting of the subject, formerly at Bridgewater House, London, and destroyed during World War II; see Salerno (note 16), cat. 161. Unlike the Chicago drawing, the ex-Ellesmere study shows no variations, either in the poses of the figures or in their scale in relation to the overall design, as compared with the painted result.

22. For more on this *modello*, see Denis Mahon and Nicholas Turner, *The Drawings of Guercino in the Collection of Her Majesty the Queen at Windsor Castle* (Cambridge University Press, 1989), cat. 23.

23. Apart from the drawings in the Ashmolean Museum and the Palazzo Rosso, there is a third recorded as in the collection of Marvin S. Sadik, Connecticut, which I have not seen; this is referred to in Mahon and Ekserdjian (note 14), under cat. XIV.

24. For more on this drawing, see ibid, cat. XIV; and Pulini, ed. (note 14), cat. 59.

25. For more on this drawing, see Piero Boccardo, *Genova e Guercino: Dipinti e disegni delle civiche collezioni*, exh. cat. (Genoa: Nuova Alfa Editoriale, 1992), cat. 21.

26. This image appears on the recto of this double-sided sheet, which is inscribed at the lower right, in pen and brown ink: *T. Zuccari*. The verso (unillustrated here) contains *Studies of a Man Riding a Pack Mule and of Figures of Christ and Saint Peter in a Composition of "Domine quo vadis?"*; these are drawn in pen and brown ink and charcoal, likewise on cream laid paper. The sketch of the man riding a pack mule is copied from an etching by Giovanni Francesco Grimaldi of a landscape with a rider; see Adam van Bartsch, *Le Peintre graveur* (Vienna; J. V. Degen, 1803–21), vol. 19, cat. 46. The reverse is inscribed as follows, vertically in two lines to the right of the sheet: *Disegni c'ho da Pietro [?] in consegna [,] Domenico Maria Fatij nummero sedici. Stampe mandate al P.[o] Ales[s]andro*

Ga[e]tani [?] *nummero sedici.* (Drawings, numbering 16 I have by Pietro [?], on consignment [,] Domenico Maria Fatij. Prints numbering 16 sent to Padre Alessandro Gaetani); below center, in pen and brown ink: "*vino ducati mille* [?]" (Wine, 1,000 *ducats*) followed by tabulated lists of numbers. The verso is also inscribed, at top center, in graphite: *14–17 19.*

27. This drawing is published in Joachim and McCullagh (note 1), cat. 64.

28. For this study in the Graphische Sammlung, Munich, see Simonetta Prosperi, *Valenti Rodinò, Pietro da Cortona e il disegno,* exh. cat. (Milan: Electo, 1997), cat. 8.6. Pietro da Cortona seems not to have made any other representations of an artist's studio. However, there is an allegorical composition of an "academy of drawing" by one of his followers, Pietro Lucatelli, in the Galleria degli Uffizi, Florence; for more on this work, see Ursula Verena Fischer Pace, *Disegni del Seicento Romano,* Cataloghi Gabinetto disegni e stampe degli Uffizi 80, exh. cat. (Florence: L. Olschki, 1997), cat. 25. In spite of the absence in Lucatelli's design of the unfolding catastrophe, there are some interesting compositional analogies between the two works. These include the allegorical figure of Drawing seated in profile at his easel, whose position recalls, in reverse, that of the unfortunate painter in Cortona's drawing.

Thurman and Brosens, Autumn *and* Winter: *Two Gobelins Tapestries after Charles Le Brun,* pp. 60–71.

1. *Autumn* and *Winter* were discussed briefly by Christa C. Mayer Thurman in *Selected Works of Eighteenth-Century French Art in the Collection of The Art Institute of Chicago,* exh. cat. (Art Institute of Chicago, 1976), cat. 311a–b; and idem, *Textiles in The Art Institute of Chicago* (Art Institute of Chicago, 1992), pp. 59, 62–63.

2. For the techniques used in this laboratory, see Yvan Maes De Wit, "The Conservation of the *Los Honores* Tapestries from the Spanish Patrimonio Nacional," in Guy Delmarcel, *Los Honores: Flemish Tapestries for the Emperor Charles V* (Ghent: Snoeck-Ducaju and Zoon, 2000), pp. 158–65.

3. John Parsons Earwaker, *East Cheshire: Past and Present; or, A History of the Hundred of Macclesfield in the County Palatine of Chester from Original Records* (London: J. P. Earwaker, 1880), vol. 2, p. 77; see http://marple-uk.com/Hall2.htm. The authors would like to thank Odile Joassin, Research Associate in the Department of Textiles, and Mark Whittaker of Marple Hall for this information.

4. On this firm and its unique role in the distribution of European tapestries in the United States, see Charissa Bremer-David, "French and Company and American Collections of Tapestries, 1907–1959," *Studies in the Decorative Arts* 11, 1 (Fall/Winter 2003/04), pp. 38–68.

5. André Félibien, *Tapisseries du Roy: Ou sont representez les quatre elemens et les quatre saisons de l'année* (Paris: Mabre-Cramoisy, 1670), p. 27.

6. Ibid., p. 37.

7. Antoine-Louis Lacordaire, "Etat-civil des tapissiers des Gobelins au dix-septième et au dix-huitième siècles," *Nouvelles archives de l'art français* 13 (1897), pp. 42–43.

8. Ibid., pp. 28–29.

9. For more on Colbert, see Roland Mousnier and Jean Favier, eds., *Un Nouveau Colbert: Actes du colloque pour le tricentenaire de la mort de Colbert* (Paris: Éditions Sedes, 1985).

10. Jules Guiffrey, *Les Gobelin* [sic], *teinturiers en écarlate au faubourg Saint-Marcel* (Paris: Daupeley-Gouverneur, 1904).

11. On the Gobelins in the seventeenth and eighteenth centuries, see Antoine-Louis Lacordaire, *Notice historique sur les manufactures impériales de tapisseries des Gobelins et de tapis de la Savonnerie* (Paris: Manufacture des Gobelins, 1853); Jules Guiffrey, "Les manufactures parisiennes de tapisseries au XVIIe siècle," *Mémoires de la société de l'histoire de Paris et de l'Ile-de-France* 19 (1892), pp. 169–292; and Maurice Fenaille, *État général des tapisseries de la manufacture des Gobelins depuis son origine jusqu'à nos jours, 1600–1900* (Paris: Hachette, 1903–23), vols. 2–4.

12. Edith Appleton Standen, "The Sujets de la Fable Gobelins Tapestries," *Art Bulletin* 46 (1964), p. 147.

13. In a low-warp workshop, weavers had to lean over the vertically positioned stationary warp threads in an uncomfortable position; high-warp workshops were more comfortable, since they required weavers to raise their arms to activate the warp threads. In both instances the weft threads were inserted through bobbins—one bobbin per color—in a horizontal direction. The cartoon was traced onto the warp threads. For more on these techniques, see François Tabard, "The Weaver's Art," in *Great Tapestries: The Web of History from the 12th to the 20th Century,* ed. Joseph Jobé (Lausanne: Edita, 1965), pp. 235–41, 257–61; and Thomas P. Campbell, "The Art and Magnificence of Renaissance Tapestries: Introduction," in idem, *Tapestry in the Renaissance: Art and Magnificence,* exh. cat. (Metropolitan Museum of Art/Yale University Press, 2002), pp. 5–6.

14. On seventeenth-century tapestry production in Paris prior to the establishment of the Gobelins, see Guiffrey (note 11), pp. 43–169; Fenaille (note 11), vol. 1; and Koenraad Brosens, "The Organisation of Seventeenth-century Tapestry Production in Brussels and Paris," *De Zeventiende Eeuw: Cultuur in de Nederlanden in interdisciplinair perspectief* 20, 2 (2004), pp. 264–84.

15. Lacordaire (note 11), p. 58.

16. The Nine Years War (1688–1697), also known as the War of the League of Augsburg, drained France of its financial resources and rendered the work of the Gobelins employees unnecessary. For more on Le Brun's work, see Henry Jouin, *Charles Le Brun et les arts sous Louis XIV* (Paris: Imprimerie nationale, 1889); Olivier Merson, "Charles Le Brun à Vaux-le-Vicomte et à la Manufacture royale des meubles de la couronne," *Gazette des Beaux-Arts* 13 (1895), pp. 89–104, 399–410; 14 (1895), pp. 5–14; Musée des Gobelins, *Charles Le Brun: Premier directeur de la Manufacture royale des Gobelins,* exh. cat. (Paris: Ministère d'État/Affaires culturelles, 1962); Jacques Thuillier and Jennifer Montagu, *Charles Le Brun 1619–1690: Peintre et dessinateur,* exh. cat. (Paris: Ministère d'État/Affaires culturelles, 1963); Michel Gareau and Lydia Beauvais, *Charles Le Brun: First Painter to King Louis XIV* (Harry N. Abrams, 1992); and Claude Nivelon, *Vie de Charles Le Brun et description détaillée de ses ouvrages,* ed. Lorenzo Pericolo, Hautes études médiévales et modernes 86 (Geneva: Librairie Droz, 2004).

17. For more on Fouquet, see Jean-Christian Petitfils, *Fouquet* (Paris: Perrin, 1999).

18. For the tapestry workshop, which was located in Maincy, see Jennifer Montagu, "The Tapestries of Maincy and the Origin of the Gobelins," *Apollo* 76, 7 (Sept. 1962), pp. 530–35; and Michel Lucas de Kergonan, *Histoire de la manufacture de tapisseries de Maincy* (Le Mée-sur-Seine: Amatteis, 2000). On the Meleager and Atalanta set, see Nicole de Reyniès, "Méléagre," in *Lisses & délices: Chefs-d'œuvre de la tapisserie de Henri IV à Louis XIV,* exh. cat. (Paris: Éditions Caisse nationale des monuments historiques et des sites, 1996), pp. 265–83; and Koenraad Brosens, "Charles Le Brun's *Meleager and Atalanta* and Brussels Tapestry, c. 1675," *Studies in the Decorative Arts* 11, 1 (note 4), pp. 5–37. On the *Portières,* see Fenaille (note 11), vol. 1, pp. 1–8; and Edith Appleton Standen, "For Minister or for King: Two Seventeenth-Century Gobelins Tapestries after Charles Le Brun," *Metropolitan Museum Journal* 34 (1999), pp. 125–34. A "portière" is a small tapestry, vertical in format, made to be hung in doorways; one accurate translation of this series' title might be "*Portières* of Fame."

19. Marc Favreau, "Le Brun aux Gobelins: Le centre de la création artistique royale sous le règne de Louis XIV (1663–1690)," in *La Maison de l'artiste: Construction d'un espace de représentations entre réalité et imaginaire (XVIIe–XXe siècles), Actes du colloque international organisé par l'Université de Poitiers (8–10 novembre 2005)* (Rennes: Presses universitaires de Rennes, forthcoming).

20. "Afin qu'il puisse voir leurs ouvrages à tous momens, qu'il les puisse corriger, et qu'il voye qu'ils avancent, et s'ils ne perdent point leur temps"; cited in Fabienne Joubert, Amaury Lefébure, and Pascal-François Bertrand, *Histoire de la tapisserie en Europe, du Moyen Âge à nos jours* (Flammarion, 1995), pp. 167–68.

21. Lacordaire (note 7), p. 27.

22. *Mercure galant,* Feb. 1690, pp. 257–60; cited in Gareau and Beauvais (note 16), p. 36.

23. "Il n'en paraissait pas content, disant que plus if faisait, plus on exigeait de lui,

sans témoignage de satisfaction"; cited in Kergonan (note 18), p. 64.

24. Fenaille (note 11), pp. 69–83.

25. The *entre-fenêtres* scenes were upgraded and became an autonomous set entitled *Child Gardeners* (first suite woven in 1685); ibid., pp. 51–185.

26. Chantal Gastinel-Coural, "Van der Meulen et la Manufacture royale des Gobelins," in *A la gloire du roi: Van der Meulen, peintre des conquêtes de Louis XIV*, exh. cat. (Dijon: Musée des beaux-arts/Luxembourg: Musée d'histoire de la ville, 1998), p. 113. On Van der Meulen, see also Isabelle Richefort, *Adam-François van der Meulen, 1632–1690: Peintre flamand au service de Louis XIV* (Rennes: Presses universitaires de Rennes/Brussels: Dexia, 2004).

27. The cartoons used by the high-warp weavers were painted by Bandrin Yvart, who executed the four large compositions; Pierre de Sève, who painted three *entre-fenêtres*; and René-Antoine Houasse, who executed the remaining *entre-fenêtre* of *Spring*; see Fenaille (note 11), p. 68. Those employed by the low-warp weavers were painted by Louis de Melun, who executed *Spring* and *Summer*; Claude Audran III, who did *Winter*; and "Ballin"—presumably Jean-Baptiste Belin—who executed the cartoon of *Autumn*. The *entre-fenêtres* were painted by Abraham Genoels II (like Van der Meulen a Flemish émigré) and one Dubois. See ibid., p. 70.

28. These copies were executed by an artist whose name is recorded only as "Mathieu"; see ibid.

29. "Il est à noter que les deux à trois premières tentures qui se font sur un nouveau dessein sont bien plus parfaites que celles qui se font après à cause que les desseins se gastent fort en travaillant"; cited in Mercedes Ferrero-Viale, "Nouveaux documents sur les tapisseries de la maison de Savoie," in *Miscellanea Jozef Duverger: Bijdragen tot de kunstgeschiedenis der Nederlanden* (Ghent: Vereniging voor de geschiedenis der textielkunsten, 1968), p. 814.

30. "*L'Hiver*, par Le Brun; sujet et tableau à conserver. . . . *L'Automne*, d'après Le Brun, hors d'état de servir. . . . *L'Été*, par Le Brun, 2 bandes; rejeté. . . . *Le Printemps*, d'après Le Brun, 8 bandes, détérioré"; see Lacordaire (note 7), pp. 257, 262–63. Maurice Fenaille recorded a total of twenty surviving fragments; see Fenaille (note 11), p. 70. There are only two fragments (inv. 3003) listed in Isabelle Compin and Anne Roquebert, *Catalogue sommaire illustré des peintures du musée du Louvre et du musée d'Orsay*, vol. 3, *Ecole française* (Réunion des musées nationaux, 1986), p. 43. Another fragment is at the Musée des Gobelins, Paris, and has not been published.

31. The high-warp set was produced in about 1680; see Fenaille (note 11), pp. 74–83. For more on the Garde-meuble, see Stéphane Castelluccio, *Le Garde-meuble de la couronne et ses intendants du XVIe au XVIIIe siècle*, CTHS histoire 15 (Paris: CTHS, 2004).

32. *Winter* and *Summer* are at the Château de Fontainebleau; *Spring* is in the Ministère de la Justice, Paris. *Autumn* is in the Ministère de l'Agriculture et de la Pêche, Paris.

33. For evidence of these assumptions, see the photo study collection of the Getty Research Institute, Los Angeles, and the files on *Autumn* and *Winter* in the Art Institute's Department of Textiles.

34. There are presently known three *Seasons* tapestries that belong to another suite made as a private commission; *Autumn* and *Winter* were at the Galerie Koller, Zürich, in 1997 (present location unknown); on the sale of *Spring*, see Christie's, Monaco, *Porcelaine, mobilier et objets d'art*, sale cat. (Dec. 3, 1989), lot 306.

35. Peter Burke, *The Fabrication of Louis XIV* (Yale University Press, 1994). On the political function of the Gobelins' production, see also Marc Favreau, "Pour une approche du mobilier royal dans les représentations diplomatiques françaises aux XVIIe et XVIIIe siècles," in *L'Objet d'art en France du XVIe au XVIIIe siècle: De La Création à l'imaginaire, Actes du colloque international organisé par le Centre François-Georges Pariset–Université Michel de Montaigne-Bordeaux 3 (12–14 janvier 2006)* (Bordeaux: Université Michel de Montaigne-Bordeaux 3, Centre François-Georges Pariset, forthcoming).

36. "Les princes et les ambassadeurs de toute l'Europe ne sortant point de France sans y être venus"; Nivelon (note 16), p. 326.

37. "Ministres étrangers pendant leur séjour à Paris, mangeant souvent avec eux"; "il n'y a pas eu, de quelque nation éloignée qui se soit rendue à la cour de Louis le Grand, qui ne soit fait un singulier plaisir de voir M. Le Brun et de converser avec lui"; ibid., pp. 327–28.

38. Fenaille (note 11), p. 77.

39. "M. Colbert nous demanda des desseins pour des tapisseries qui devaient se faire à la manufacture des Gobelins. Il en fut donné plusieurs entre lesquels on choisit celui des quatre éléments, où on trouva le moyen de faire entrer plusieurs choses à la gloire du roi. . . . On fit ensuite le dessein de la tenture des quatre Saisons de l'année sur le modèle de celle des quatre elements"; see Charles Perrault, *Mémoires de ma vie*, ed. Paul Bonnefon (Paris: Renouard, 1909), p. 39, cited in Gastinel-Coural (note 26), p. 113.

40. "A rendu les saisons plus belles & plus fécondes"; see Félibien (note 5), p. 1.

41. "Tant de vertus qui éclarent en Elle [Sa Majesté], sont les mesmes vertus pour lesquelles l'Antiquité dressoit des Autels"; ibid., p. 27.

42. "Que si le Roy prend aussi quelque part à ces passe-temps, c'est sans rien perdre des heures qu'il destine à ses occupations plus importantes"; ibid., p. 37.

43. "On a peint dans chaque Tableau une Maison Royale choisie entre les autres, comme celle qui a le plus d'agrément dans la Saison où elle est représentée"; ibid., p. 1.

44. "Le Louvre. . . . On voit la grande Galerie & les gros Pavillons, qui décorent ce superbe Palais"; ibid., p. 37.

45. N. Avel, "Les Pérelle: Graveurs de paysages du XVIIme siècle," *Bulletin de la société de l'histoire de l'art français* (1973), pp. 143–53.

46. Jacques Hillairet, *Dictionnaire historique des rues de Paris* (Paris: Éditions de Minuit, 1972), vol. 1, p. 379. A map issued in 1648 shows the Porte de la Conférence in bird's-eye view; see Jean Boutier, *Les plans de Paris des origins, 1493, à la fin du XVIIIe siècle: étude, carto-bibliographie et catalogue collectif* (Bibliothèque nationale de France, 2002), pp. 139–41.

47. On the Fronde, see Orest Ranum, *The Fronde: A French Revolution, 1648–1652* (W. W. Norton, 1993); and Michel Pernot, *La Fronde* (Paris: Éditions de Fallois, 1994).

48. For more on the Tuileries, see Pierre-Nicolas Sainte Fare Garnot and Emmanuel Jacquin, *Le Château des Tuileries* (Paris: Herscher, 1988); and Nicolas Sainte Fare Garnot, *Le décor des Tuileries sous le règne de Louis XIV* (Réunion des musées nationaux, 1988).

49. For more on the castle, see Georges Lacour-Gayet, *Le Château de Saint-Germain-en-Laye* (Paris: Calmann-Lévy, 1935).

50. Fenaille (note 11), pp. 51–66.

51. "Changé tous les Elemens qui étoient dans une confusion horrible"; Félibien, p. 3.

52. Fenaille (note 11), pp. 166–85. See also Donald Posner, "Charles Le Brun's *Triumphs of Alexander*," *Art Bulletin* 61, 3 (1959), pp. 237–48; Thuillier and Montagu (note 16), pp. 71–73, 77–95, 258–59, 264–75, 278–79, 288–301; Lydia Beauvais, "Les dessins de Le Brun pour *l'Histoire d'Alexandre*," *Revue du Louvre* 40, 4 (1990), pp. 285–95.

53. Fenaille (note 11), pp. 98–127; Thuillier and Montagu (note 16), pp. 330–35; Daniel Meyer, *L'Histoire du Roy* (Réunion des musées nationaux, 1980); Gastinel-Coural (note 26), pp. 110–20.

54. T. Sauval, "Recherches sur la tenture dite des mois ou des Maisons royales," *Bulletin de la Société de l'histoire de l'art français* (1961), pp. 59–64; Charissa Bremer-David, "Tapestry 'Le Château de Monceaux' from the series Les Maisons Royales," *J. Paul Getty Museum Journal* 14 (1986), pp. 105–12; Gérard Mabille, "Le grand buffet d'argenterie de Louis XIV et la tenture des Maisons royales," in *Objets d'art: Mélanges en l'honneur de Daniel Alcouffe* (Dijon: Faton, 2004), pp. 181–91.

55. On the *Portières des Dieux*, see Fenaille (note 11), pp. 1–60; and Nello Forti Grazzini, *Gli arazzi, Il Patrimonio artistico del Quirinale* (Rome: Editoriale Lavoro, 1994), vol. 2, pp. 416–39. On *Don Quixote*, see Fenaille (note 11), pp. 157–282; Forti Grazzini (above), pp. 392–415; and Thierry Lefrançois, *Charles Coypel: Peintre du roi (1694–1752)* (Paris: Arthena, 1994).

McCullagh, *"A Finesse of the Crayon": Eighteenth-Century French Portraits in Pastel, pp. 72–87.*

1. The museum's first significant pastel purchase was Jean-Baptiste Perronneau's *Portrait of the Marquis de Puete-Fuerte*; for more on this work, see *Selected Works of Eighteenth Century French Art in the Collection of The Art Institute of Chicago* (Art Institute of Chicago, 1976), cat. 48; Harold Joachim, *French Drawings and Sketchbooks of the Eighteenth Century*, microfiche compiled by Sandra Haller Olsen (University of Chicago Press, 1977), p. 48, 2D. For more on Helen Regenstein and her collection, see Harold Joachim, *The Helen Regenstein Collection of European Drawings*, exh. cat. (Art Institute of Chicago, 1974); and *Art Institute of Chicago Museum Studies* 26, 1 (2000).

2. In 1665 Dumonstier's son Nicolas was the first artist elevated to the Royal Academy as a painter of pastel portraits; see Joanna M. Kosek, "The Heyday of Pastels in the Eighteenth Century," *Paper Conservator* 22 (1998), p. 2.

3. Ibid., p. 2, n. 8.

4. Ibid, pp. 1–9.

5. Ibid, pp. 6–7.

6. Ibid.

7. See, for example, Christine Debrie and Xavier Salmon, *Maurice-Quentin de La Tour: Prince des pastellistes* (Paris: Somogy éditions d art, 2000). For an illustration of the finished pastel in the Louvre, see Christie's London, *Old Master and 19th Century Drawings including Andrea del Sarto's "Saint Joseph,"* sale cat. (Christie's, July 5, 2005), lot 162.

8. This work followed in the footsteps of two important earlier ones. The first is an impressive oil portrait of Coypel's younger brother Philippe on the eve of his marriage (1732; Musée du Louvre, Paris); see Thierry Lefrançois, *Charles Coypel, peintre du roi (1694–1752)* (Paris: Arthena, 1994), cat. 142. The second is a pastel self-portrait (1734; J. Paul Getty Museum, Los Angeles) that he gave to his brother as a testimony of their deep friendship; see ibid., cat. I.4.

9. Geneviève Monnier, *Pastels from the 16th to the 20th Century* (Skira, 1984), p. 29.

10. This approach had already figured in two of Coypel's earlier paintings; see the impressive pendant portraits *Madame and Mademoiselle Dupillé* and *Monsieur Dupillé* (1733; private collection), reproduced in Lefrançois (note 8), cats. 155–56.

11. *Mercure de France*, Sept. 1742, p. 2055, as cited in ibid., p. 324. It appears that Coypel also executed a now-lost pastel pendant for this portrait, *Portraits de Trois enfants parents de l auteur*; see ibid., cat. 216 and a similar image on p. 324. One confusing issue, noted by Lefrançois, is that Philippe Coypel apparently had only two daughters.

12. Abbé Pierre-François Guyot Desfontaines, "Exposition des Tabl. De l Acad. De P. & de S.," in *Observations sur les écrits modernes* (1735–43), vol. 29, p. 353, as cited in Lefrançois (note 8), p. 324.

13. For more on La Tour's campaign of slander, see "Portrait of Jean-Baptiste-Antoine Le Moyne," *Art Institute of Chicago Museum Studies* 26, 1 (2000), cat. 19.

14. Jean François Méjanes describes the Louvre portrait as "coiffé d'une perruque et orné d un jabot"; see Xavier Salmon et al., *De Poudre et de papier: Florilège de pastels dans les collections publiques françaises* (Versailles: Artlys, 2004), p. 50. For all portraits of Lemoyne, see Albert Besnard and Georges Wildenstein, *La Tour: La vie et l oeuvre de l artiste* (Paris: Les Beaux-arts, édition d'études et de documents, 1928), cats. 269–71.

15. "Le portrait du Sieur Lemoine celebre sculpteur, représenté tel qu on le voit ordinairement dans son atelier, c est à dire dans le négligé d un homme vraiment occupé." As quoted by Jean François Méjanes in Salmon et al. (note 14), cat. 16. For many years, it was assumed that the Louvre version had been made later, but Méjanes noted that Lemoyne (even without his wig) is surely closer to the age of forty-three that he was in the Dormeuil version, and the idea that he could be fifty-nine in the Louvre painting has to be excluded.

16. Alan Wintermute, *The French Portrait, 1550–1850*, exh. cat. (New York: Colnaghi, 1996), p. 44.

17. For more on Mondonville, see Christine Debrie, *Maurice-Quentin de La Tour: "Peintre de portraits au pastel" 1704–1788; au Musée Antoine Lécuyer de Saint-Quentin* (Thonon-Les-Bains: Albaron/Saint-Quentin: Musée Antoine Lécuyer, 1991), pp. 144–45.

18. Pierre-Jean Mariette, *Abécédario de Mariette et autres notes inédites de cet amateur sur les arts et les artistes*, Archives de l Art Français 3 (Paris: Dumoulin, 1854–56), p. 73.

19. A second version is now in the Musée Antoine-Lecuyer, Saint-Quentin; see Salmon et al. (note 14), cat. 4.

20. Pierre Estève, letter to a friend on the exhibition of the paintings made in the great Salon du Louvre of August 25, 1753, as cited in Besnard and Wildenstein (note 14), p. 54.

21. Mariette (note 18). According to Adrian Bury, La Tour's meaning was that "he could not consider the feelings of persons who did not share his high opinion of the Italian comedians who at the moment had divided Paris into two musical camps, those for and those against them. La Tour was in favour of the Italians. Mme de Mondonville was not"; see Adrian Bury, *Maurice Quentin de La Tour, The Greatest Pastel Portraitist* (London: Skilton, 1971), p. 48. Indeed, it appears as though Madame de Mondonville was trying to get away with paying half price. According to sources at the University of Chicago (with thanks to Lauren Lessing, formerly of the Ryerson and Burnham Libraries), it is my understanding that 1 golden *louis* was worth 24 silver *livres* hence 25 *louis* would have amounted to 600 *livres*. Before the Revolution, a *livre* was worth about 20 cents and a *louis* $4.80, making Madame de Mondonville's offer $124, the silver plate she bought worth about $144, and the going rate for a portrait by La Tour $248.

22. These pastels remained in the same family since the 1920s. Long forgotten, they were known in the nineteenth century by the replicas that La Tour had made of them and remained part of his estate at the time of his death. The Musée Antoine Lécuyer, Saint-Quentin, possesses a version of *Portrait of Monsieur de Mondonville* that measures 65 x 55 cm (25 5/8 x 21 5/4 in.) and is thus larger than the Art Institute's; for more on this work and its provenance, see Bury (note 21), pl. 54. Two replicas of *Portrait of Madame de Mondonville* are known: one is in the St. Louis Art Museum and the other was part of the collection of J. Pierpont Morgan; for more on these, see Besnard and Wildenstein (note 14), cats. 349–50.

23. For an illustration of this work, see Debrie and Salmon (note 7), pl. 46.

24. Denis Diderot is reputed to have characterized him thus: "This extraordinary man . . . who abandoned the art in which he excelled in order to immerse himself in the metaphysical depths which would lead him to go mad" (Cet homme singulier . . . qui a abandonné l'art dans lequel il excelle pour s'enfoncer dans les profondeurs de la métaphysique qui achèvera de lui déranger la tête); see Christine Debrie, "Maurice-Quentin de La Tour: Peintre de portraits au pastel et Peintre du Roi, 1704–1788," *Versalia* 1 (1998), p. 31.

25. For more on this will, see Musée de l'Orangerie, Paris, *Le Portrait français de Watteau à David* (Éditions des musées nationaux, 1957), cat. 52.

26. For more on this work, see Emile Dacier and Paul Ratouis de Limay, *Pastels français des XVIIe et XVIIIe siècles*, exh. cat. (Paris: G. van Oest, 1927), cat. 60; Geneviève Monnier, *Musée du Louvre, Cabinet des dessins : pastels, XVIIème et XVIIIème siècles* (Éditions des musées nationaux, 1972), cat. 78; Salmon et al (note 14), cat. 12.

27. For more on the Art Institute's version, see Dacier and Limay (note 26), cat. 60.

28. See Geneviève Monnier, Maurice-Quentin de La Tour, in *The Dictionary of Art*, ed. Jane Turner (Grove, 1996), vol.18, p. 841.

29. For more on both works, see Suzanne McCullagh and Pierre Rosenberg, "The Supreme Triumph of the Old Painter: Chardin's Final Work in Pastel," *Art Institute of Chicago Museum Studies* 12, 1 (1985), pp. 43–59.